UNCUT CLOTH

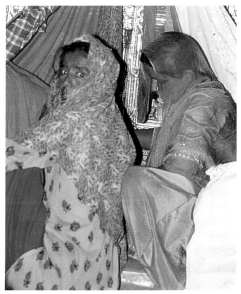

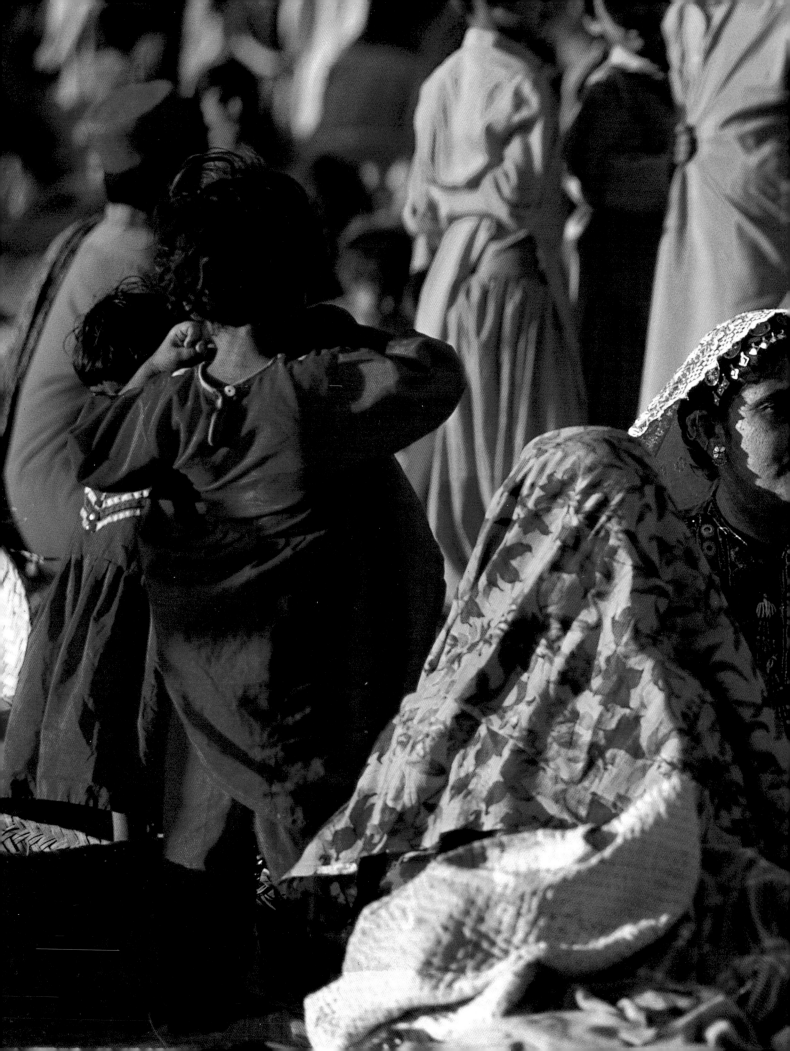

UNCUT CLOTH

NASREEN ASKARI

LIZ ARTHUR

MERRELL HOLBERTON
PUBLISHERS LONDON

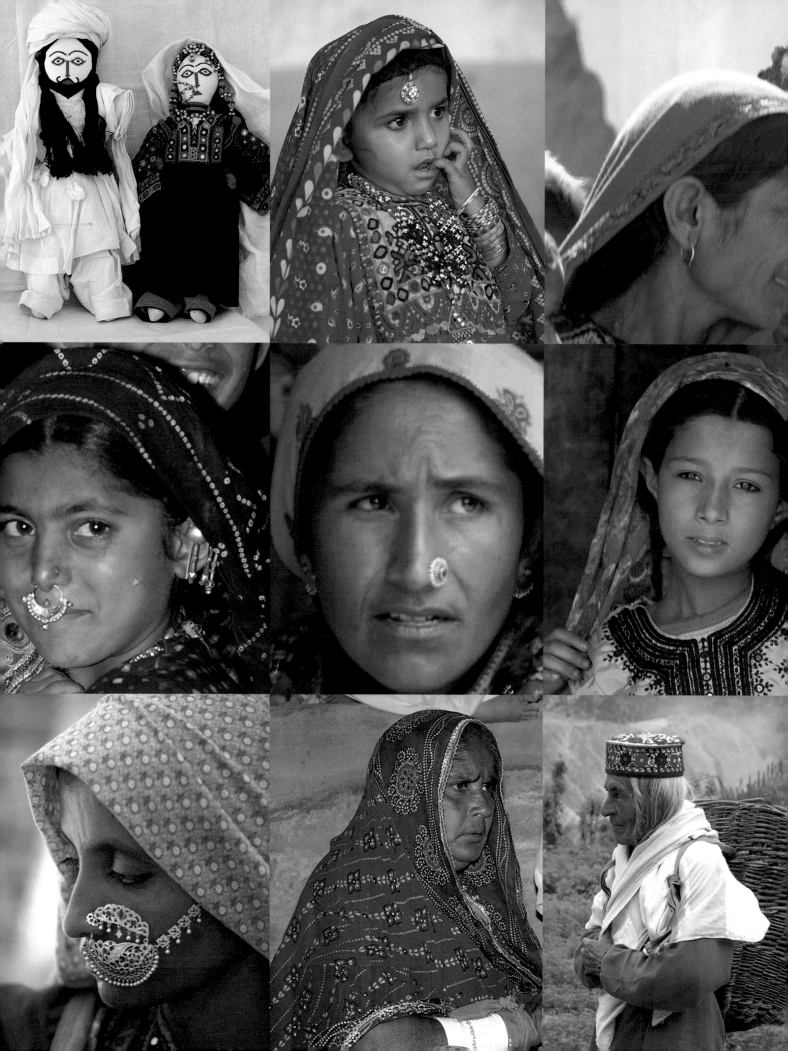

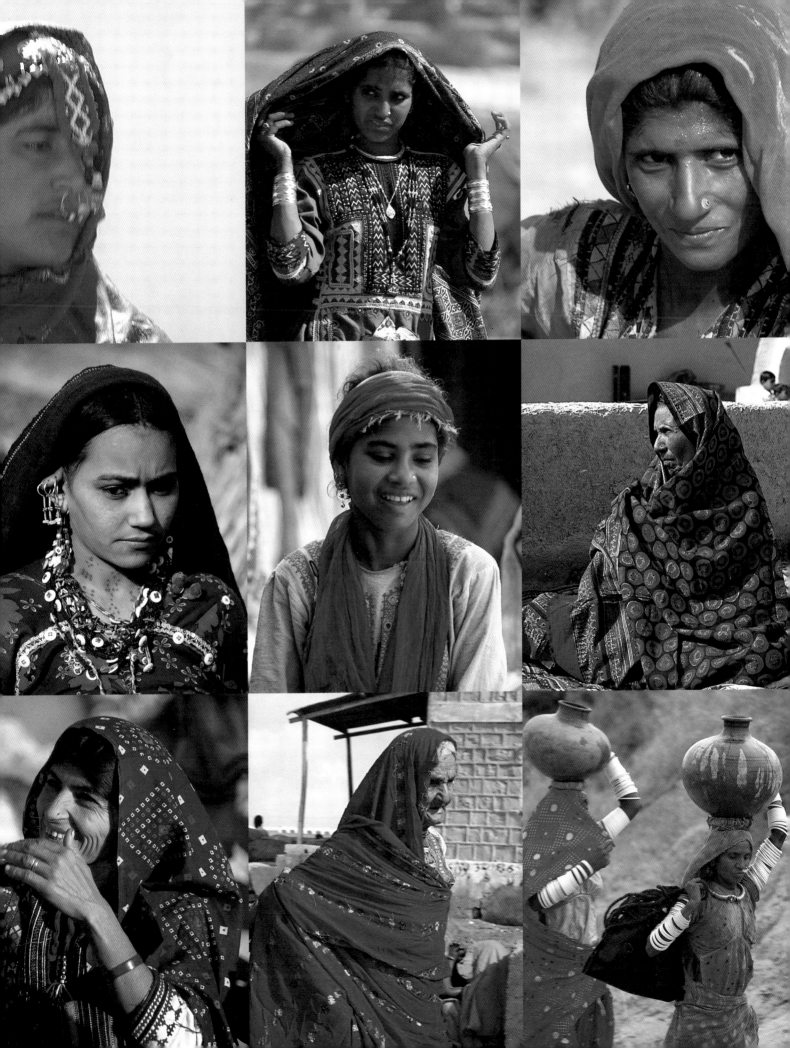

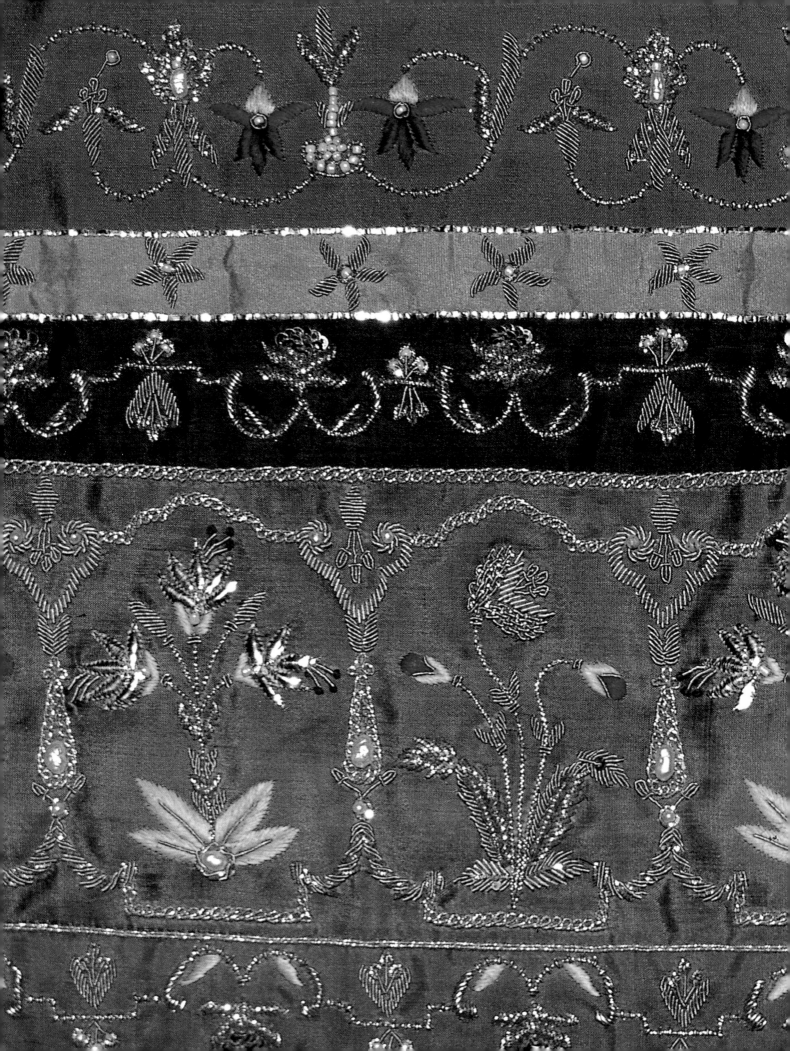

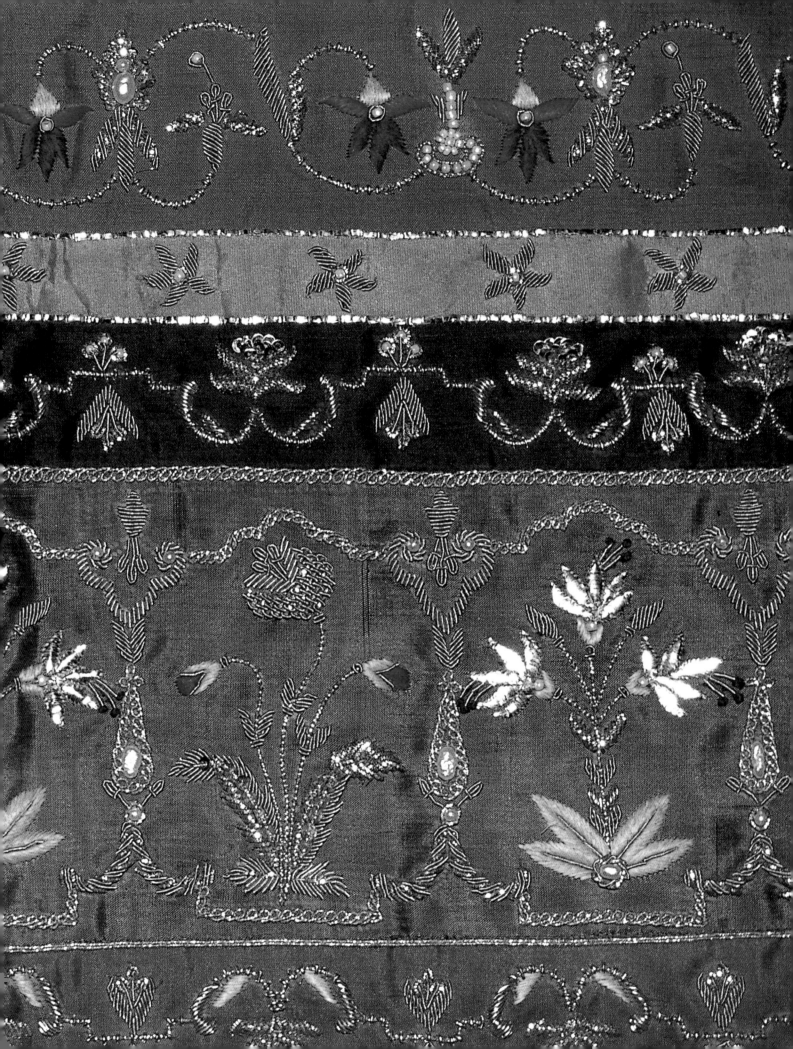

Published on the occasion of the exhibition *Uncut Cloth: Saris, Shawls and Sashes* at the Paisley Museum and Art Galleries,
19 June – 24 October 1999

First published 1999 by Merrell Holberton Publishers Limited

Text © Nasreen Askari, Liz Arthur and Paisley Museum and Art Galleries

Photographs © as credited on page 127

British Library Cataloguing-in-Publication Data
Askari, Nasreen
Uncut cloth : saris, shawls and sashes
1.Textile crafts – India 2.Textile crafts – Pakistan
I.Textile II.Arthur, Elizabeth
746.0954
ISBN 1 85894 083 4

Produced by Merrell Holberton Publishers Limited
Willcox House, 42 Southwark Street, London SE1 1UN

Distributed in the USA and Canada by Rizzoli International Publications, Inc. through St Martin's Press, 175 Fifth Avenue, New York, New York 10010

Designer: Roger Davies

Printed and bound in Great Britain

Cover and pages 18–19
Man's wedding shawl (*doshalo*)
Meghwar group, Tharparkar, Sindh
Early 20th century
Cotton with silk embroidery, applied mirrors
L: 226 cm W: 104 cm

Back cover
Vendor of devotional offerings at the shrine (*dargah*) of Abdullah Shah Ghazi, Karachi, Sindh, 1997

Half-title page
Women tying their headshawls (*dupattas*) to the door of the shrine (*dargah*) of Shah Abdul Latif, Bhitshah, Sindh, 1993

Title page
Women clad in vibrant shawls, Shah Godrio, Dadu, Sindh, 1997

Pages 4–5
Headshawls: for details see adjacent column

Pages 6–7
Detail of a large bridal headshawl (*doshalo*), Karachi Sindh, 1997. Collection Faiza Samee

Copyright page
Rabari woman, Kasbo, Tharparkar, Sindh, 1996

Contents Page
Yarn drying on a rooftop, Mohalla Tajpura, Khushab, Punjab, 1999

Pages 10–11
Festival of Gaji Shah, Dadu, Sindh, 1996

Pages 12–13
Turbans: for details see page 14

Pages 14–15
For details see page 14

Pages 4–5

Headshawls have a variety of regional names in South Asia (*odhani, gandi, bandhani, poti, chundari, dupatta, chadar, suri, doshalo, ajrak* or *maleer*).

TOP ROW, LEFT TO RIGHT

A set of Baluchi dolls dressed in traditional costume, Lahri, Baluchistan, 1996. The male doll is wearing a voluminous cotton turban (*pag*), with a shawl (*pushti*) over his shoulder. The female doll is wearing a shawl (*suri*) with an embroidered tunic and loose trousers.

Soomrah girl from Kutch in a printed shawl simulating a tie-dyed pattern (*chundari*), with a gold ornament (*bundi*) on her forehead

Khosa Baloch women wearing headshawls (*gandi*) with embroidered patterns. Nose rings, amulets and ornaments in the hair are traditionally worn by married women. The band in front of the woman's face supports her nose ring. Thano Bula Khan, Sindh.

Woman wearing a resist-printed and mordant-dyed shawl (*ajrak*), Manghopir Fair, Karachi

Brohi woman in an embroidered blouse front (*gaj*) wearing a plain headshawl (*gandi*). Women are obliged to keep their heads, particularly the middle parting of the hair (*seendh*), covered. Shahdadkot, Sindh.

MIDDLE ROW, LEFT TO RIGHT

Girl from a Rabari herding group in a traditional tie-dyed shawl (*bandhani*) and a printed tunic (*cholo*). She has been given an ornament through the septum in her nose but will wear another ring in the side of her nose when she comes of age. Shah Bandar, Indus delta.

Khosa woman with her head covered in a *chadar*, Bahawalpur, Punjab

Memon girl wearing a *dupatta*, Ladiyun village, Indus delta

Kutchi Rabari girl wearing a woollen *odhani*, near Lakhpat, Kutch

Odh gypsy girl with a *dupatta*, Sanhipul village, Cholistan, Punjab

Woman wearing a large, printed *maleer*, Mirpurkhas, Tharparkar, Sindh

BOTTOM ROW, LEFT TO RIGHT

A farmer's wife at home wearing a factory-printed cotton *odhani*, Dishak group, Hatrhi, Sindh

Maheshwari woman wearing a printed *odhani*, Ahmedabad, Gujarat. The orange handkerchief (*rumal*) around her wrist is a votive offering for a vow.

Woman in the Hunza Valley, Northern Areas, Pakistan, favour plain shawls (*chadar*) over intricately embroidered caps

Palari woman in a printed *chundari*, Thano Ahmed Khan, Dadu, Sindh

Woman at a bus stop, Thatta, Indus delta. She is wearing a headshawl (*poti*) with machine-made embroidery known as *chikankari*.

Kohli women in *odhanis* carrying terracotta pots and a buffalo-skin water-carrier outside Jaipur, Rajasthan

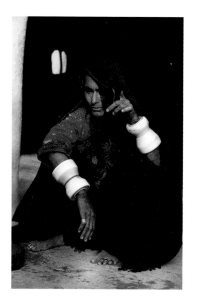

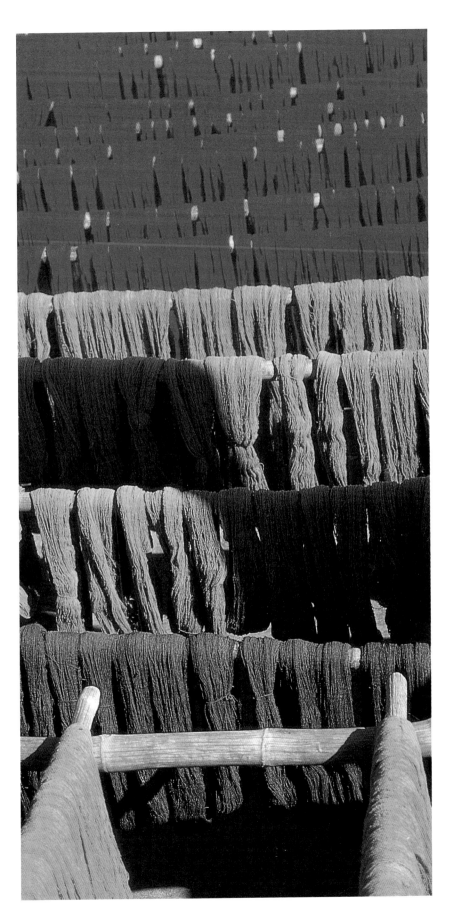

CONTENTS

PREFACE 17

THE CONTINUING TRADITION 20
Nasreen Askari

INTRODUCTION 20
THE SARI 23
SHAWLS AND HEAD COVERINGS 39
TURBANS 65
WAISTCLOTHS AND SKIRTS 74
SPREADS, COVERLETS AND CANOPIES 84

TRADE IN UNCUT CLOTH 99
Liz Arthur

COTTON 100
TURKEY RED 101
EXPORTS TO SOUTH ASIA 104
EXHIBITIONS 109
THE CONTINUING LINK 110

THE PAISLEY SHAWL 113
Valerie Reilly

FURTHER READING 127
PICTURE CREDITS 127
INDEX 128

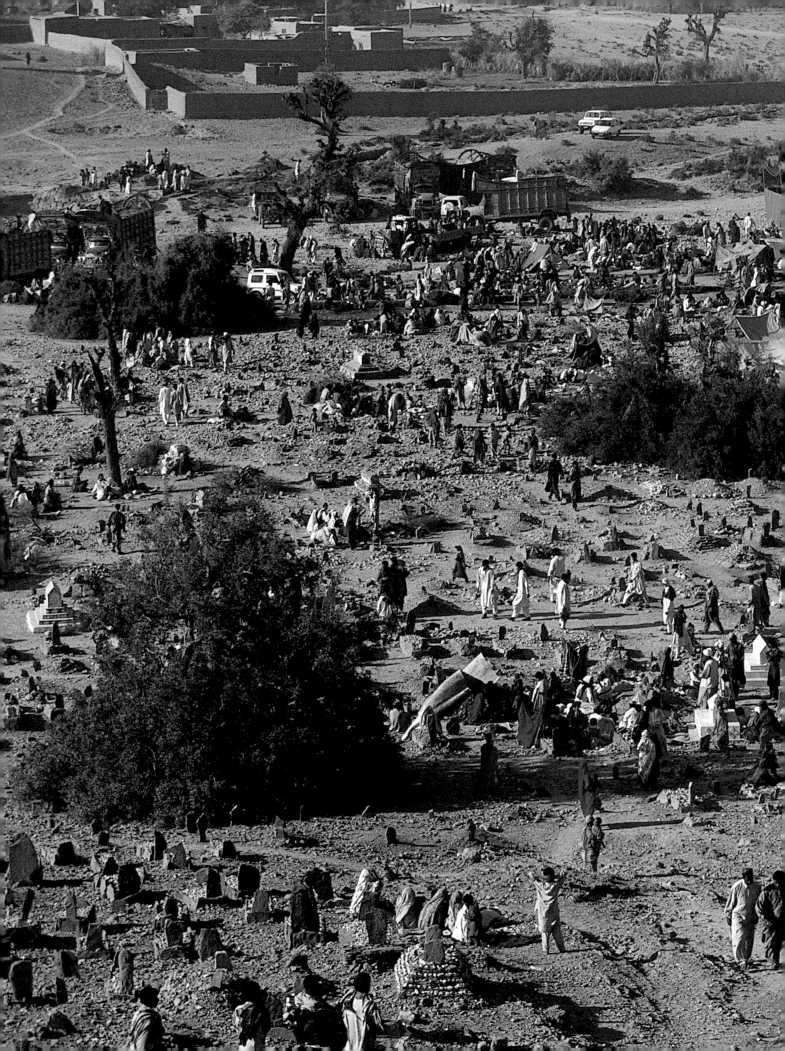

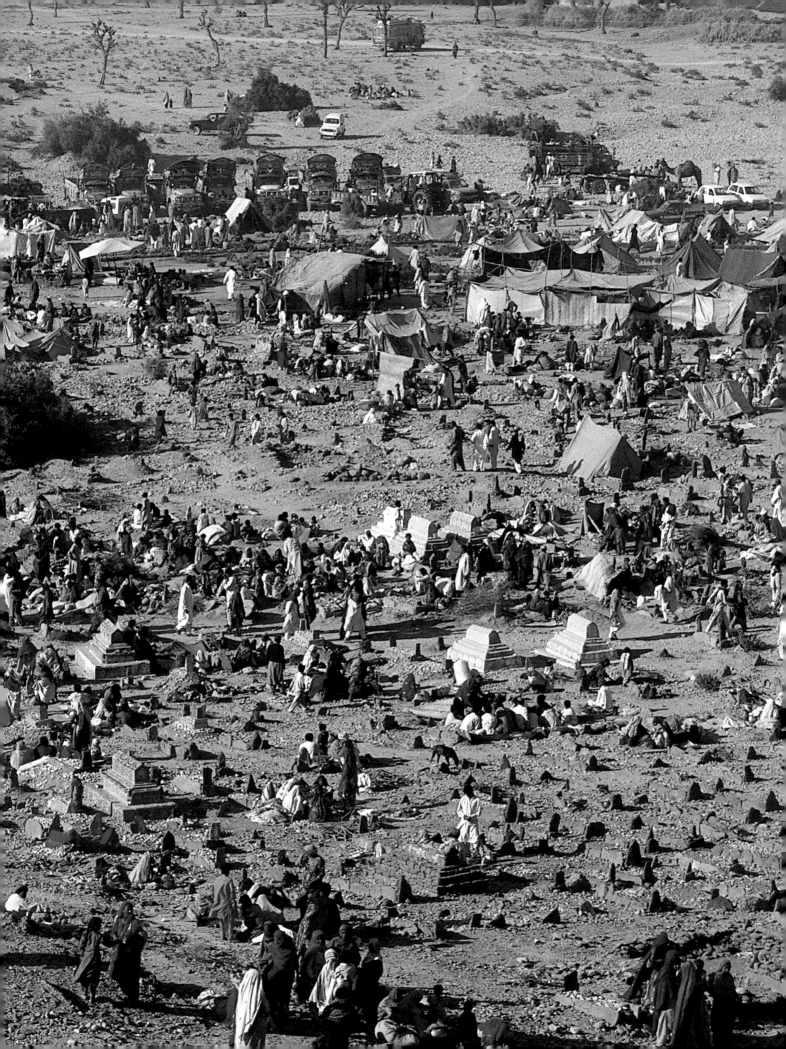

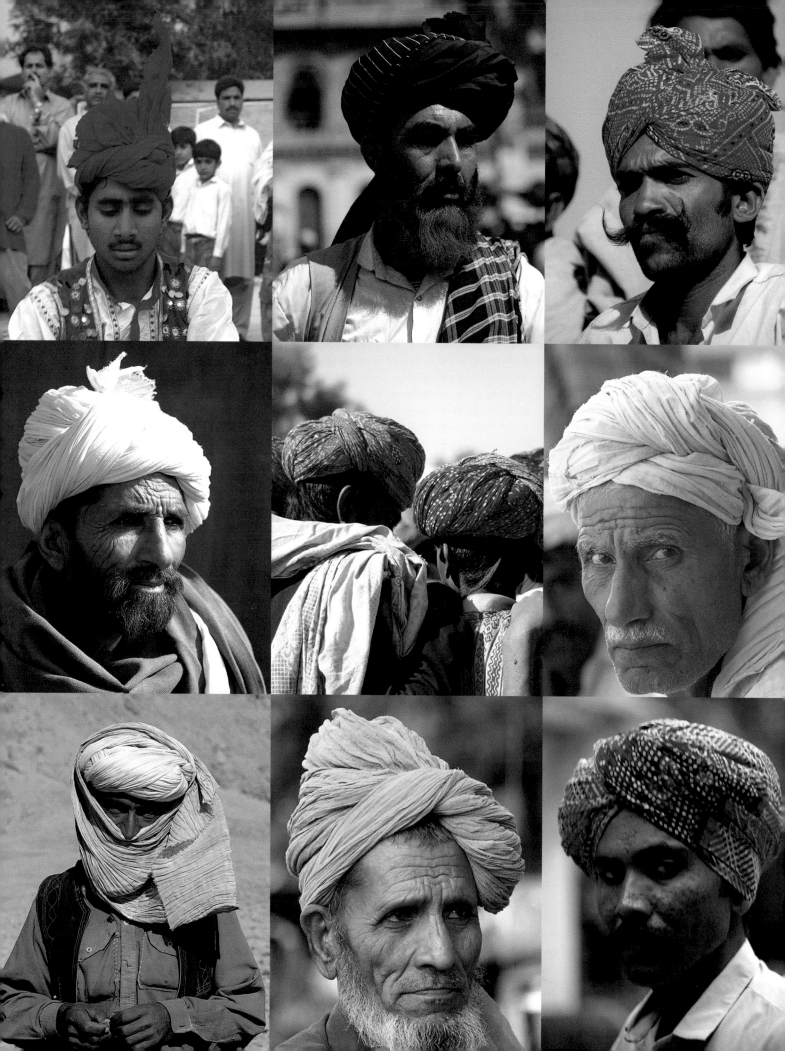

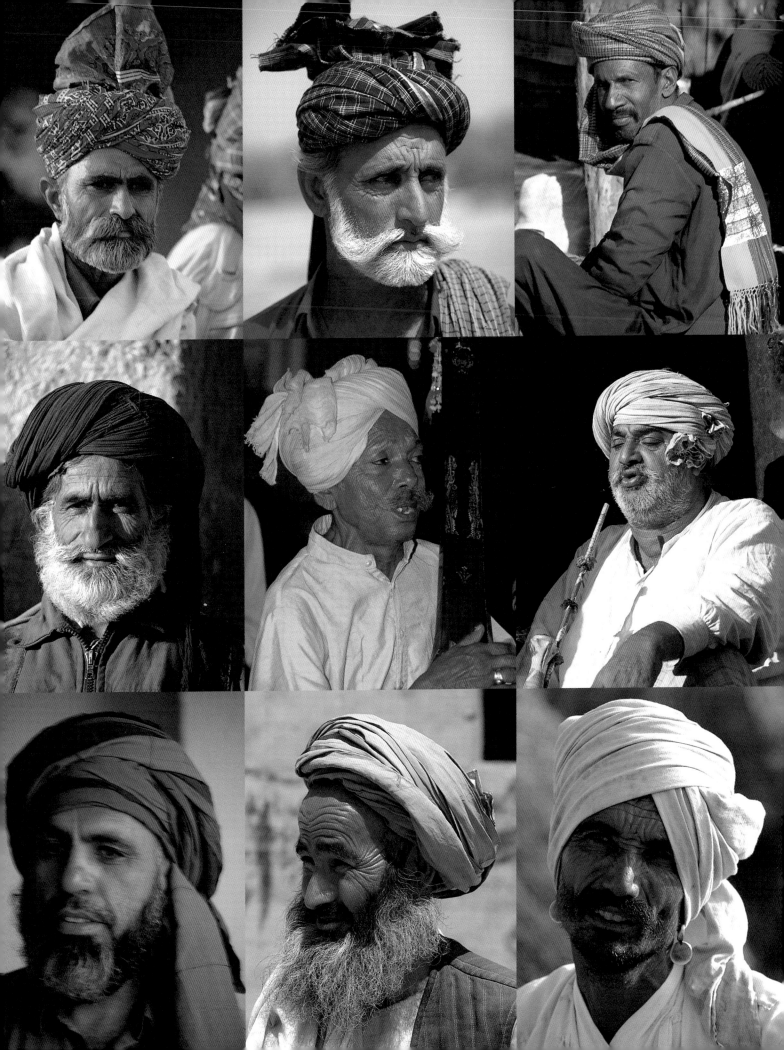

Pages 12–13

TOP ROW, LEFT TO RIGHT

Folk dancer, Islamabad, Punjab

Pathan, Naushera, North West Frontier

Thakur, Barmer, Rajasthan

Sindhi farmer wearing an *ajrak* turban and a white cotton shawl, Padidan, Sukkur, Sindh

Nuhani herdsman, Naing, Dadu, Sindh

A *salara* shawl worn as a turban, Khushab bazaar, Punjab

MIDDLE ROW, LEFT TO RIGHT

A farmer, Sadiqabad, Bahawalpur, Punjab

Pushkar fair, Rajasthan

Lohana, Ahmedabad, Gujarat

A Bugti, Dera Bugti, Baluchistan

Bhagat musician, Rajasthan

An Arain shopkeeper, Kalabagh, Punjab

BOTTOM ROW, LEFT TO RIGHT

A Marri, Kahan, Sulaiman range, Baluchistan

Jullunder, East Punjab

A Bhil, Delhi

Pathan, Waziristan, North West Frontier

Pathan, Charsadda, North West Frontier

A Rabari, Umarkot, Tharparkar, Sindh

RIGHT
Men's shawls (*salaras*) on pitlooms,
near Sargodha, Punjab, 1999

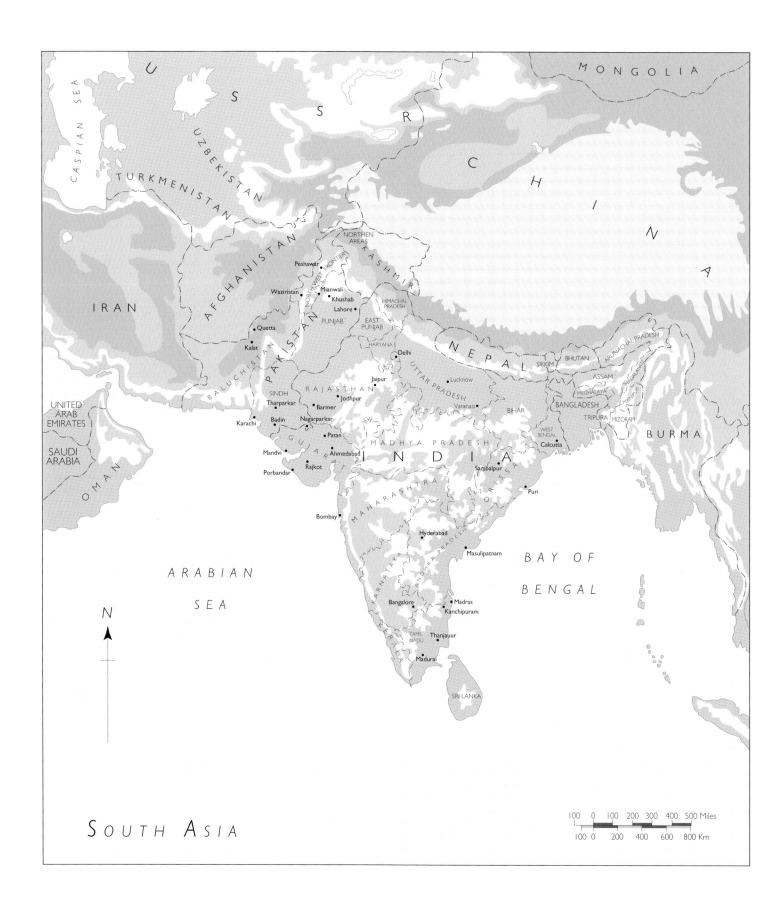

MONGOLIA

CASPIAN SEA

U S S R

C H I N A

UZBEKISTAN

TURKMENISTAN

AFGHANISTAN

IRAN

NORTHERN AREAS

KASHMIR

Peshawar

NORTH WEST FRONTIER

Waziristan • Mianwali
• Khushab
• Lahore

HIMACHAL PRADESH

NEPAL

ARUNACHAL PRADESH

Quetta

PUNJAB

EAST PUNJAB

Kalat

PAKISTAN

HARYANA

Delhi

SIKKIM

BHUTAN

ASSAM

NAGALAND

UNITED ARAB EMIRATES

BALUCHISTAN

SINDH

RAJASTHAN

Jaipur

UTTAR PRADESH

Lucknow

MEGHALAYA

MANIPUR

SAUDI ARABIA

Tharparkar • Barmer • Jodhpur

Varanasi

BIHAR

BANGLADESH

TRIPURA

MIZORAM

BURMA

Karachi

Badin • Nagarparkar

GUJARAT

Patan

MADHYA PRADESH

I N D I A

WEST BENGAL

Calcutta

Mandvi
Porbandar • Rajkot

• Ahmedabad

Sambalpur

ORISSA

OMAN

Puri

Bombay

MAHARASHTRA

ARABIAN SEA

ANDHRA PRADESH

Hyderabad

BAY OF BENGAL

Masulipatnam

KARNATAKA

N

Bangalore • Madras
Kanchipuram

KERALA

TAMIL NADU

Thanjauur

Madurai

SRI LANKA

100 0 100 200 300 400 500 Miles
100 0 200 400 600 800 Km

SOUTH ASIA

PREFACE

This book arose out of our shared sense of the cultural and artistic significance of uncut cloth in the societies of South Asia. This region is not in itself unique in the importance it attaches to uncut cloth in rituals of life, love, worship and death, but the diversity of the traditions here has made this particular effort that much more interesting. This book, like the exhibition at the Paisley Museum and Art Galleries which it accompanies, is designed to be illustrative of this diversity and to encourage further thought and interest.

Any exhibition that is a collection of objects from a number of individuals and institutions inevitably entails the assistance of a great many people, not all of whom wish to be publicly acknowledged, but to all of whom we remain grateful.

From among a whole host of people, we should like to thank Elizabeth Guest and Sarah Sumsion, who conceived the accompanying exhibition. Our financial supporters, The Scottish Arts Council, National Lottery New Directions Programme, The Caram Trust, Charles Wallace India and Pakistan Trusts, INTACH UK Trust, Ardkinglas Arts Trust, J.F. Denholm Trust, Scottish India Arts Forum, Chivas Brothers, Glasgow Airport Authority, Merchants House of Glasgow, The Trades House of Glasgow, Glasgow 1999 UK City of Architecture and Design, The Incorporation of Weavers, The Paul Hamlyn Foundation. The Walter Guinness Trust, Coats, Crafts UK, Jennifer Raikes, Renfrewshire Enterprise and Renfrewshire Council, were all unstinting in their support of the exhibition, education and community programmes, Particular

thanks to the Paisley Museum and Art Galleries staff, especially Dan Coughlan, Jennifer Evans, Catherine Harbon, Sharon de Meza, Valerie Reilly and Laura Sim, for their consistent help. The Uncut Cloth Steering Committee of Minoo Das, Elisabeth Gibson, Elizabeth Guest, Nosheena Mobarik, Valerie Reilly, Baron Singh and Sarah Sumsion worked tirelessly through the intervening months to make the associated events possible. Our considerable thanks are owed to all the lenders, Cartwright Hall, Bradford, Glasgow Museums, Glasgow University Archive, the National Museum of Scotland, Sindh Provincial Museum, Pakistan, Kirsty Aiken, Jilli Blackwood, Elizabeth Chatwin, Minoo Das, Jasleen Dhamija, Kim Gourlay, Joss Graham, Mr and Mrs Henson, Shehnaz Ismail, Banto Kazmi, Sandi Kiehlmann, Vaishali Londhe, Maria Mackellar, Sarbijit Natt, Deirdre Nelson, Ruby Palchoudhury, Mary Restieux, Faiza Samee, Jayne Sanderson, Sarah Sumsion and Suki Vir, for sharing their objects with us. For their helpful advice and concouragement we should like to thank Shushma Bahl of the British Council, Delhi, Helen Bennett, Monica Clough, Anne Morrell, Maggie Paterson and Carmel Roy. For their practical assistance we thank the members of the Renfrewshire and Paisley branches of the Embroiderers' Guild. We are also indebted to our two photographers, Ellen Howden in Scotland for the studio photographs and Mohammed Ali Qadri in Pakistan for field photography. Rosemary Crill gave of her time with comments on the manuscript, Akbar Khushk typed it and Hasan Askari acted as an effective though voluntary literary agent.

Nasreen Askari
Liz Arthur
1999

THE CONTINUING
TRADITION

Nasreen Askari

Come, let us to the weaver go,
So steadfast is his creed,
Binds he continually the thread,
And ne'er lets it snap.[1]

INTRODUCTION

Of the enormous range of textiles used in the South Asian subcontinent, for daily or ceremonial use, single lengths of uncut cloth are certainly the most versatile and the most popular. In their diverse forms, they reflect the aesthetic ideals of the groups who live in this large geographical area. Evolution in style and adornment notwithstanding, the primary function of an unsewn length of cloth continues unchanged, whether as sari, shawl, waistcloth, turban, sash, spread or wrap.

Draped garments worn by groups within the subcontinent were affected by influences from West and Central Asia that accompanied invasions, trade and immigrant groups before the first millennium BC. These influences may have led to the adoption of stitched garments such as trousers and jackets that were better suited to the newcomers' horse-riding culture and climate. Today, the eastern and southern areas of the subcontinent continue to adhere to traditional styles of draped costume, principally the sari for women, with the loincloth (*dhoti*) and shoulder cloths (*uttariya*) for men, while the north and western regions have adopted stitched garments more widely.

NOTE
1. Translation from Shah Abdul Latif (1689–1752), *Sur Kapaiti* (Ode to a weaver).

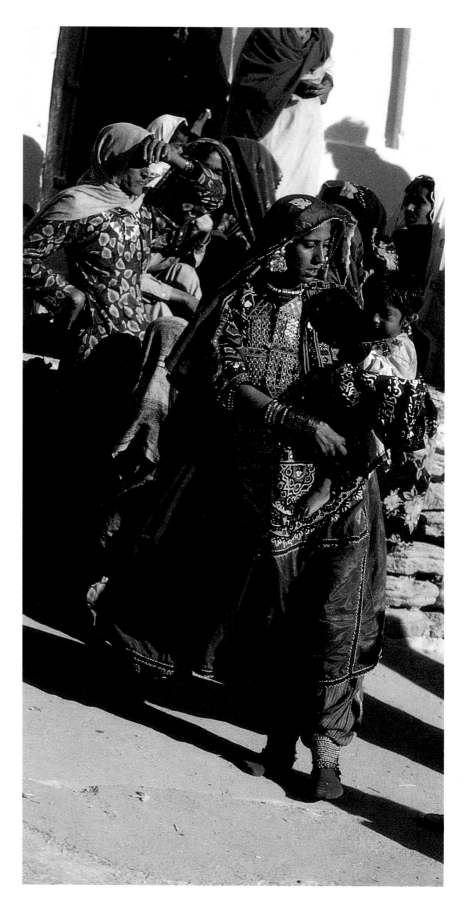

1

A Khosa Baloch woman carrying a devotional offering to the shrine of Gaji Shah, patron saint of Khosa herdsmen. Festival of Gaji Shah, Dadu, Sindh, 1996. The offering seen here is a length of green silk decorated with a verse from the Quran.

In many parts of the subcontinent, men's costume consists of headgear and two main garments, one covering the upper half of the body (variously known as a *kurta, kameez, angrakha, pairhan* or *bunyan*), the other the lower half. If uncut cloth is used for the latter it is referred to as a *dhoti* or *lungi*. If stitched in the form of trousers, it is commonly known as a *paijama* or *shalwar*. Women's costumes usually comprise three garments: a single uncut length of cloth, the sari, worn over a petticoat with a bodice or blouse (*choli*), or a headshawl (*gandi, dupatta, chadar* or *odhani*) over a tunic (*kurta* or *kameez*) and gathered trousers (*shalwar*) or skirt (*gaghra*). In Bangladesh, costume generally consists of a waistcloth (*lungi*) for men and saris for women. Among traditional tribal communities in the north-east of India, readily available natural materials have always been used for weaving and embellishing assorted wraps that make up both male and female costume.

Cloth is often imbued with a sanctity of its own. In the unsewn form, especially, it is considered holy or sacred and gifts consisting of lengths of cloth have deep-rooted resonances in many of South Asia's Hindu and Muslim religious traditions. It also constitutes an important form of social interaction, conforming to relationships dictated by family and community ties. Uncut cloth is often used as a baby's first swaddling band, a circumcision wrap, coming-of-age veils for girls, the ritual gifts for marriage and the final enveloping shroud for burial (*kafan*). The end of a widow's formal period of mourning (*idath*) is symbolically marked by the presentation of a length of cloth, usually a sari or a headshawl (*dupatta*). With this gift, she prepares to return to the routine chores of her life. During *Hajj*, the Muslim pilgrimage to Mecca, devotees wrap themselves in lengths of unadorned white cloth, the *ahram*, before circumambulating the *Kaaba*. Muslim mendicants and Hindu holy men (*sadhus* or *yogis*),

monks and followers of certain religious orders, usually wear robes of uncut cloth. These may be yellow (*pitambari*), saffron (*gairu*), black (*siyah*) or green (*sabz*), all colours with spiritual significance. Friends and relatives spread offerings of decorated cloth, including large shawls (*chadars*) and turban cloths (*lungis*), as valedictory gifts at funerals. Specially woven, painted or embroidered cloths in the form of coverings, hangings or canopies are presented at temples all over South Asia, as an integral part of Hindu religious worship (*puja*). In Tamil Nadu it is mandatory to wear unsewn cloth as a prelude to worship, and in Bengal women make offerings of saris to appease the gods. In Muslim devotional practice, cloths often serve as votive offerings in fulfilment of vows, a ritual referred to as a *manath*. At festivals or *urs* (the anniversaries of Sufi saints), devotees spread brightly coloured lengths of cloth adorned with flowers, tinsel or embroidered verses from the Quran, on the graves of the saints (fig. 1).

Rituals involving gifts of uncut cloth for young girls and women are very important. As a girl reaches puberty, her first headshawl (*dupatta*) evolves from a length of simple cotton cloth casually draped over her shoulders and occasionally over her head, into an indispensable and decorated part of her daily attire. Several headshawls are skilfully embellished to make up her bridal trousseau (*jahez* or *dej*). The most elaborate version of these, the *doshalo*, will have one of its corners knotted to her groom's *doshalo* as they leave her parents' house. In Gujarat, a bride's sari is often draped in another sari of red cotton, with a woven gold check pattern containing auspicious tie-dyed motifs, a *gharcholu* (fig. 2). In parts of the Punjab, a groom may wear an elaborately embroidered cotton shawl, a *phulkari* (literally 'flower work'), worked on by the female members of his family, which he presents to his bride as part of their wedding rituals.

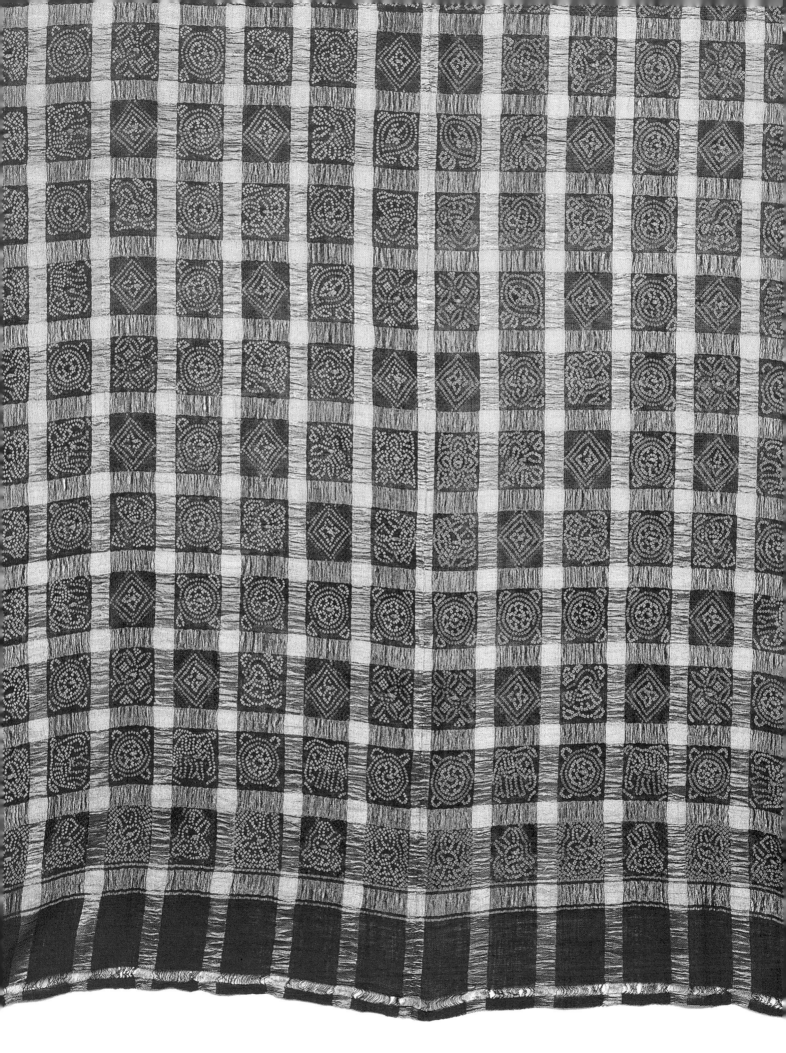

Sari (*gharcholu*), detail
Probably Porbandar, Saurashtra,
Gujarat
Mid 20th century
Cotton, tie-dyed with
supplementary wefts in gold
thread
L: 452 cm W: 123 cm
Collection Nasreen Askari
Almost always red, a *gharcholu*
sari is a gift from a groom to
his bride. She usually wears it
over her own wedding sari and
one end of it is symbolically
knotted to a corner of his
shawl during their wedding
ceremony. This example shows
white, yellow and green tie-
dyed motifs of dancers,
elephants, birds and stylized
lotus flowers.

THE SARI

A sari is the most commonly seen costume of unstitched cloth worn by women across South Asia. Varying in size, style, pattern, colour and richness, it crosses all class and caste barriers; regional traditions and urban fashions continue to contribute to its repertoire of design forms. Each area in India has its own distinctive method of draping a sari. One end is generally worn tucked at the waist into a petticoat, pleated and then wound around the legs to make a long skirt reaching to the ankles; the remaining end may be thrown over a shoulder or over the head. A widow is frequently expected to wear a white sari, older women wear dark tones, while bright colours are reserved for younger women. Wedding saris are often red, as it is an auspicious colour, although in Kerala they tend to be white.

A sari may vary in length from about three to eight metres and is usually considered in three parts: a field, an end-piece and borders along the length. The field may be plain, printed or embroidered, with plain or patterned borders. The width and decoration of the borders are dictated by regional variations and often help to distinguish between areas of origin. The end-piece (*pallu* or *palan*) is usually draped over the shoulder and may be embellished. Although there is an infinite variety of ways of tying a sari, the commonest style adopted by the urban middle class today is referred to as the *nivi*. In the north, the decorated end-pieces tend to be large and are worn over the bosom. The Deccan style is sometimes worn to create the effect of a pair of trousers, by being wound loosely or tightly around the legs, in a complicated draping sequence. Also referred to as the *kathi*, this style is found in Maharashtra, Andhra Pradesh, Madhya Pradesh and South India, particularly Karnataka and Tamil Nadu. The Dravidian style, which is indigenous to South India,

has the pleats of the sari put in place before it is wound around, with one end draped over the front of the body. Tribal women in the north-east Karnakatah and eastern Deccan wear saris knotted at the shoulder or pinned (figs. 3, 5). In Gujarat, Rajasthan and parts of Haryana, half saris known as *odhanis* are worn with skirts (*gaghras*) or waistcloths (*lungis*). Two-piece saris are found in other areas, such as, in Assam, the ceremonial silk shawl (*chadar*) and waistcloth (*mekhala*), which are worn together.

Saris from Gujarat, Rajasthan, Haryana, Uttar Pradesh and Madhya Pradesh are known for their techniques of adornment, using block printing, resist dyeing and embroidery. Patterns vary in complexity and are often made up of borders and end-pieces with motifs of intertwining vines (*bel*) and large bands (*pheta*), which are circumscribed by narrow geometric borders or continuous scrolls (*kungri* or *gadh*). The field of the sari is often plain or has small scattered motifs (*buti*), varying from simple dots to elaborate floral, mango or paisley outlines (fig. 7). Block-printed saris in Saurashtra and Kutch often have a transparent resinous glue stamped on to the ground fabric with flakes of mica or gold-coloured dust scattered over it (*roghan*; fig. 6).

Gujarat, Orissa and Andhra Pradesh are also major centres for *ikat* dyeing, an ingenious method of resist dyeing in which yarns are selectively dyed before being woven (fig. 4). A ceremonial sari created in this technique in Gujarat is the renowned *patolu* (plural: *patola*). *Patola* saris have three characteristic types of patterns: geometric, floral and figurative. Saris with geometric patterns are thought to have been exported to South East Asia since at least the fourteenth century. Those with floral patterns traditionally favoured by the Bohra and Ismaili communities are known as leaf (*bhat*) designs (fig. 8). Figurative patterns that depict dancing women (*nari*), elephants (*kunjar*) or parrots (*popat*) continue to be choice ceremonial gifts in

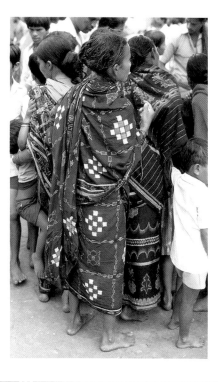

3 FAR LEFT

A tribal sari, worn knotted at the shoulder, Kotpad village, Orissa, 1994

4 LEFT

Women wearing locally woven *ikat* saris, Puri, Orissa, 1987

5 BELOW

Sari, detail

Bastar, Madhya Pardesh. Mid 20th century. Woven cotton. L: 568 cm W: 112 cm

Private collection Jasleen Dhamija

Dyed with a local dye, *al* (*Morinda citrifolia*), this striking sari has had its white pattern woven in a supplementary weft technique.

6 FACING PAGE

Sari, detail

Probably Masulipatnam, Andhra Pradesh. Mid 20th century. Resist-printed cotton

L: 536 cm W: 120 cm

Private collection Jasleen Dhamija

This indigo-dyed sari is described as having a *kalamkari* (penwork) design named after a pen-like tool that was used to apply resist on to the cloth. *Kalamkari* saris were exported to the European market in the seventeenth century and Masulipatnam continues as an important sari-producing centre. Patterns now tend to be block printed rather than hand drawn.

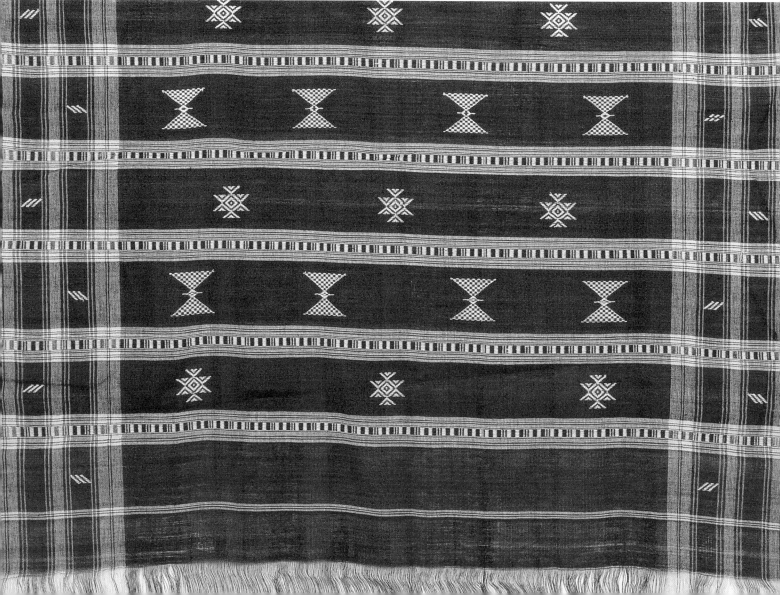

7 ABOVE
Sari, detail
Kaira district, Gujarat. Late 19th century. Printed cotton. L: 480 cm W: 105 cm
Glasgow Museums, 88.109 bt
The design of this traditional sari from western India shows a strong Mughal
influence in the patterns of its field, borders and end-piece.

8 FACING PAGE
Sari (patolu), detail
Probably Surat, Gujarat. Late 19th century. Silk, double ikat. L:406 cm W: 94 cm
Glasgow Museums, 88.109 ar
The repeating circular floral pattern of this magnificent silk double ikat is known as
the chhabadi bhat or basket design.

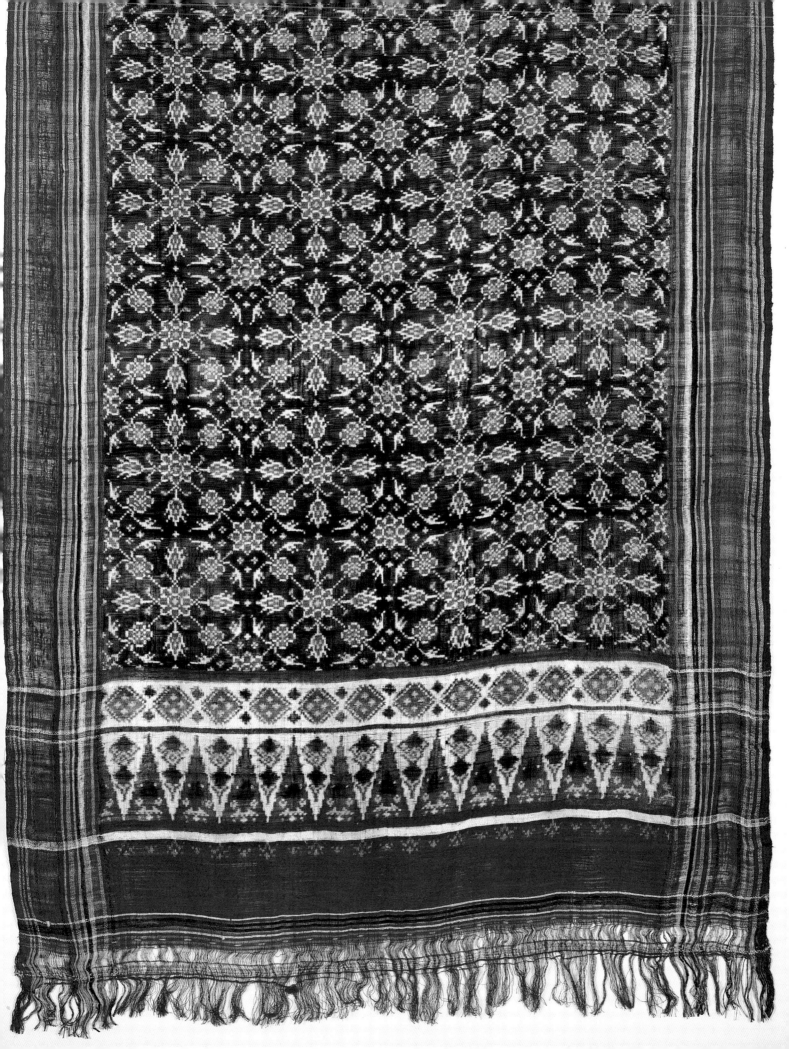

9 FACING PAGE
Sari (*telia*), detail
Chirala, Andhra Pardesh
Early 20th century
Cotton with warp and weft
ikat
L: 500 cm W: 114 cm
Collection Jasleen Dhamija
This unusual sari is an
elaborate version of a *telia
rumal*, a square textile
commonly found in South India
as a shawl, waistcloth or
handkerchief in which the warp
and weft threads are dyed in a
predetermined pattern before
being woven. The *telia rumal*
pattern relies on the use of
small *ikat* motifs in a trellis with
borders all around that form
squares at the corners. Silver-
wrapped thread has been used
to highlight the sari's black
borders and to create a fine
check pattern between them
and the field.

10 RIGHT
Sari, detail
Kutch, Gujarat
Mid 20th century
Gajji silk, tie-dyed
L: 310 cm W: 108 cm
Collection Jasleen Dhamija
Dancers, elephants, birds, leaves
and stylized flowers are seen in
this sari pattern, which has
been tie-dyed in the traditional
red and black colours favoured
by brides of Khatri dyer groups
in Kutch. The end-piece (*pallu*)
has been further embellished
with a woven band of gold-
wrapped thread.

Gujarat, especially linked to *simant*, a ceremony that takes place in the seventh month of pregnancy. The *patolu* is thought to protect the mother and ensures a safe birth. The other major form of resist-dyeing technique in Gujarat is the tie-and-dye method (*bandhani*) in which patterns are created by knotting or tying specific areas of cloth to prevent them from being dyed. Well-known centres for *bandhani* saris in Saurashtra include Jamnagar, Rajkot and Porbandar with Bhuj, Anjar and Mandvi in Kutch (figs. 9, 10).

Decorating saris with metallic threads (*zardozi*) is popular in the urban centres. This technique employs gold and silver threads or wires stitched on to the surface of cloth. Depending on the materials used, different textures and effects can be achieved: *kalabatun* is a term used to describe silk thread wrapped with gold wire, *naqshi* is a tightly coiled fine gold wire, *salma* is a fine faceted wire, while beaten and flattened wire is called *kamdaani*. *Zardozi* work is used to decorate saris and costumes for ceremonial and formal wear (fig. 11).

Saris from South India tend to have fields of simple plaid or striped patterns with plain or contrasting borders and end-pieces, while saris from the North favour floral and more ornamental motifs (fig. 12). The Kornad sari from Tamil Nadu is one of South India's better-known designs in which the field of the sari is a traditional plaid (*kattani*) or striped (*saarai, adyar*) pattern, often with a plain wide border. Elaborate versions may have end-pieces with a series of widely spaced stripes woven in gold-wrapped thread (*zari*) or bands of *zari* containing weft-wise triangular points. Less ambitious versions use an additional colour instead of the *zari* (fig. 13). Traditional Kornad saris (although the village of Kornad no longer functions as a weaving centre) and a number of sari types woven throughout South India are commonly referred to as temple saris because of their *rekhu* motif, a

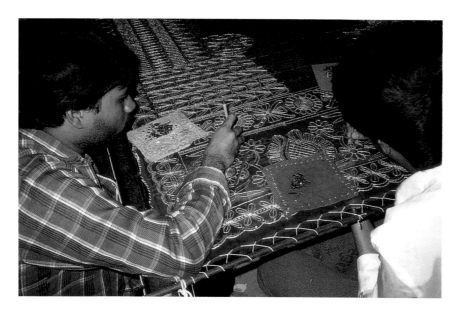

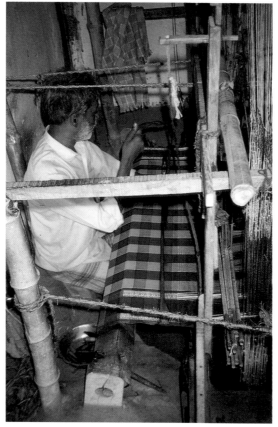

11 ABOVE
Craftsmen working on gold-thread embroidery (*zardozi*), Jamnagar, Gujarat, 1994

12 RIGHT
A checked cotton Chettinad sari being woven in a warp *ikat* technique, Karaikudi, Tamil Nadu, 1996

13 FACING PAGE
Kornad sari, detail
Tamil Nadu
20th century
Woven silk
L: 520 cm W: 117 cm
Collection Jasleen Dhamija

continuous tooth or serrated pattern on the borders that protrudes into the field. Temple saris used as devotional offerings or for ritual worship (*puja*), which are popular all over Tamil Nadu, tend to be somewhat smaller in length than conventional saris and are most frequently offered as gifts to deities (figs. 14, 15). The *kanchivani* saris of Kanchipuram in Tamil Nadu are well known for their sumptuous woven end-pieces (*palan*) using thick *zari* threads in different supplementary warp and weft patterns (fig. 18). This technique is still practised in Maharashtra and Orissa and the motifs tend to be drawn from nature and the forms of temple architecture.

The eastern areas of India, comprising the states of Bengal, Bihar and the eastern aspect of Uttar Pradesh, have traditionally been centres for silk cultivation and weaving. Varanasi, still popularly known as Banaras, is renowned for its distinctive woven silk designs based on the Mughal repertoire (fig. 16). One type of Banaras silk brocade sari called the *amru* consists of a transparent silk field with silk or gold-wrapped thread incorporated into it in a supplementary weft technique (fig. 17). The supplementary threads used to create patterns are often so fine that the ground fabric appears as if it had been printed.

Baluchari saris derive their name from the town of Baluchar, situated on the River Bhagirati in Bengal. The classical Baluchari sari is an intricately woven silk brocade containing an end-piece with a single paisley or mango motif, a *kalga*, framed within a square. This is, in turn, surrounded by borders that enclose figures, animals or floral motifs. The field of the sari often contains small scattered motifs of flowers or floral sprays (*buti*) with elaborately patterned floral borders (fig. 19). *Jamdaani* saris from Bangladesh with woven patterns in fine cotton (unlike the silk of the Baluchari school) are outstanding in their use of a discontinuous supplementary weft technique. Two

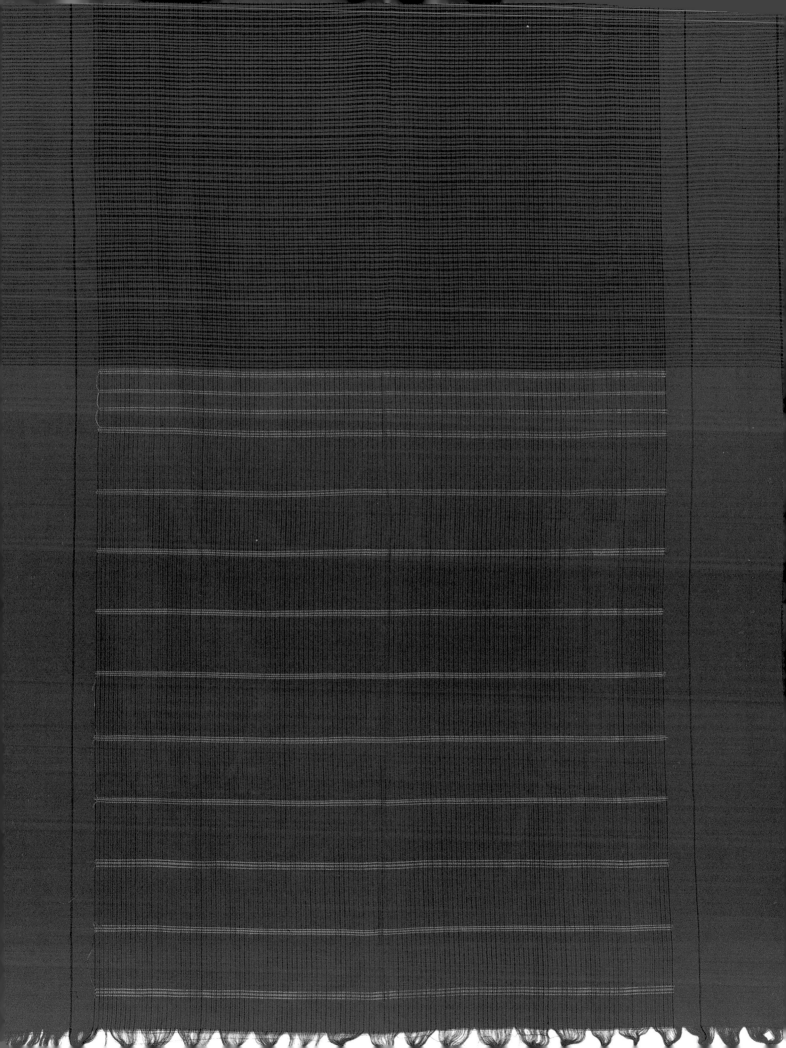

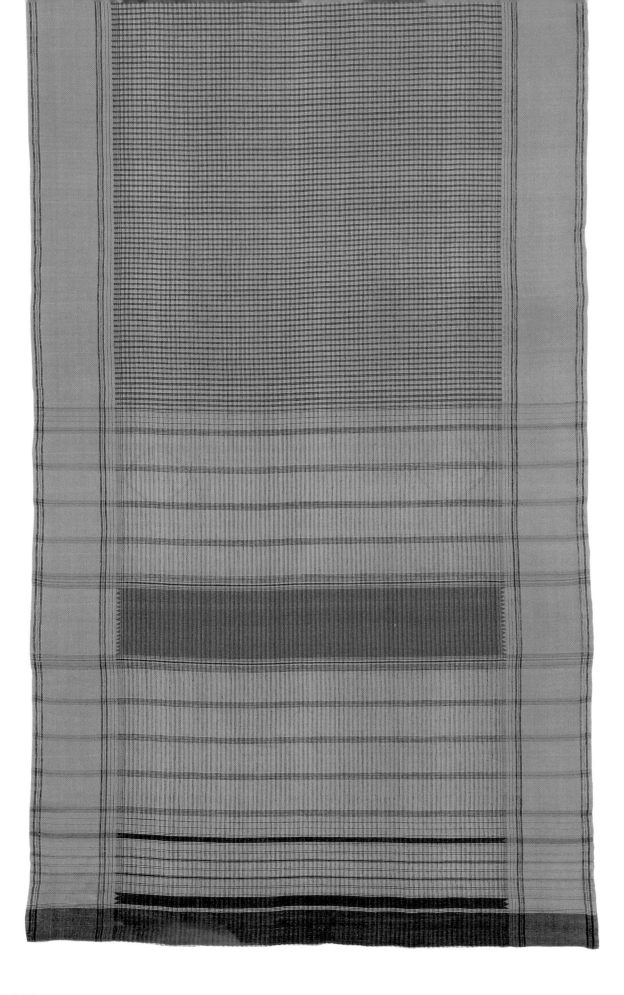

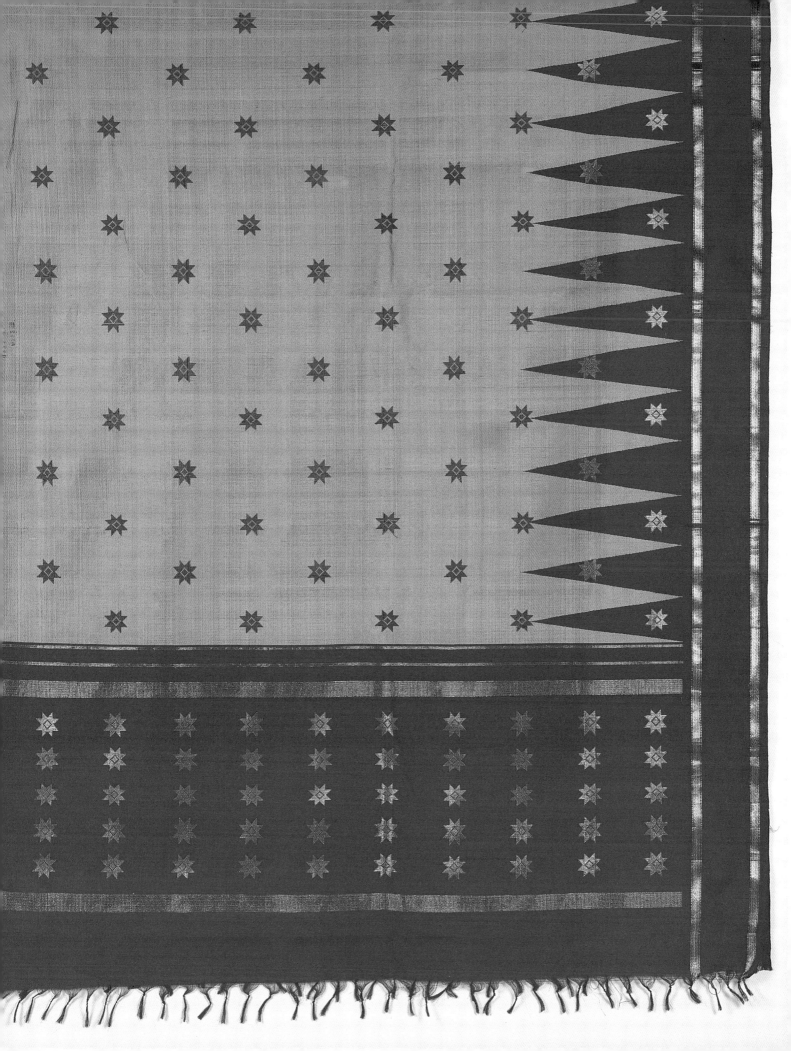

16 LEFT
A Banarasi sari weaver, Banaras, 1992

17 BELOW
Sari, detail
Banaras, Uttar Pradesh
ca. 1920
Silk woven with silver and gold brocade
L: 800 cm W: 126 cm
Collection Sir Stewart Mitford Fraser

18 FACING PAGE
Sari, detail
Probably Kanchipuram, Tamil Nadu
20th century
Silk and gold brocade
L: 486 cm W: 118 cm
Collection Mrinalini Sarabhai

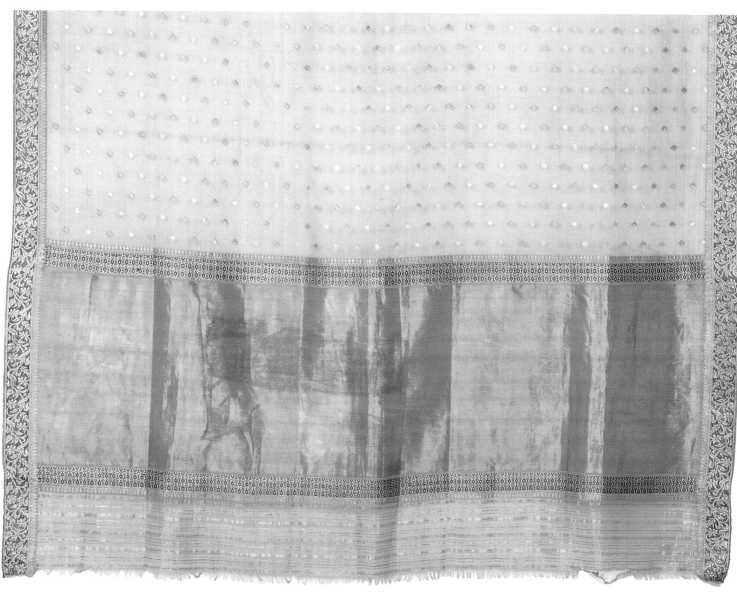

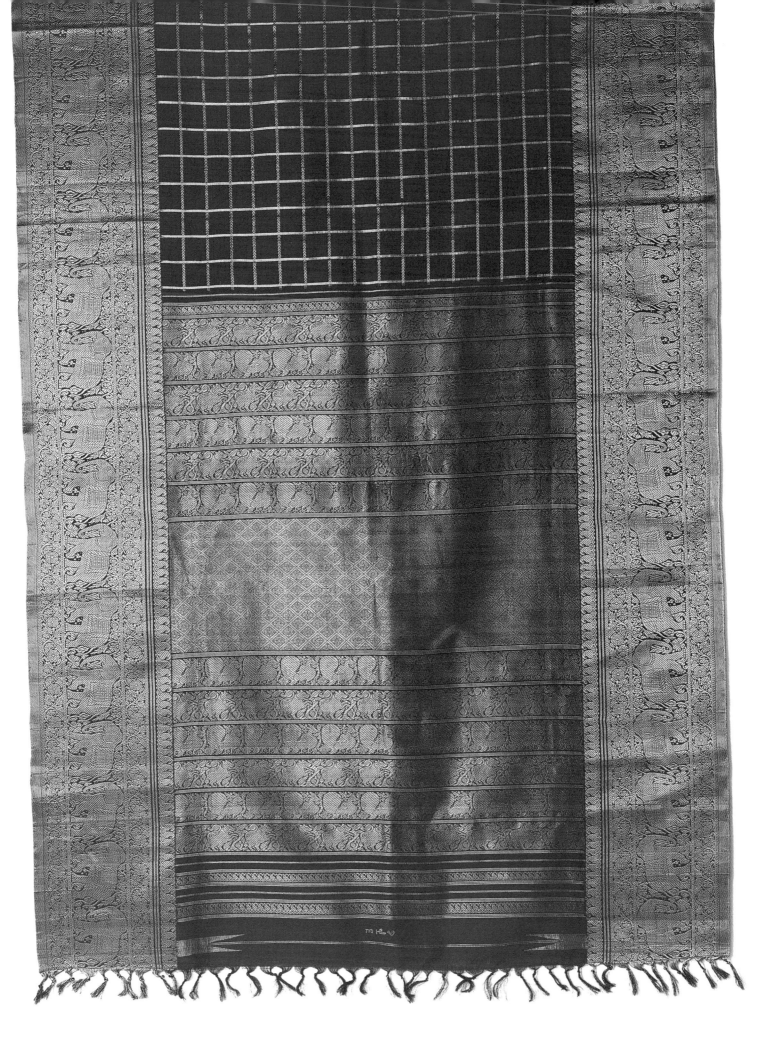

weavers work simultaneously on a handloom and
insert threads for individual motifs. Modern
jamdaani saris have a remarkable gauze-like
appearance and generally have a small scattered
field motif with decorative floral end-pieces (fig. 20).

20 FACING PAGE
Sari (*jamdaani*), detail
Dhaka, Bangladesh. 20th century. Cotton with supplementary cotton wefts. L: 560 cm W: 119 cm
Private collection
This sheer cotton sari has had its pattern skilfully created with red cotton woven in a supplementary
weft technique.

19 BELOW
Sari, end-piece (*pallu*), detail
Baluchar, Bengal. Early 20th century. Woven with silk. L: 440 cm W: 113 cm
Collection Ruby Palchoudhury
The detail of a pictorial border in the elaborate end-piece of this Baluchari sari shows Indian and
European figures in railway carriages.

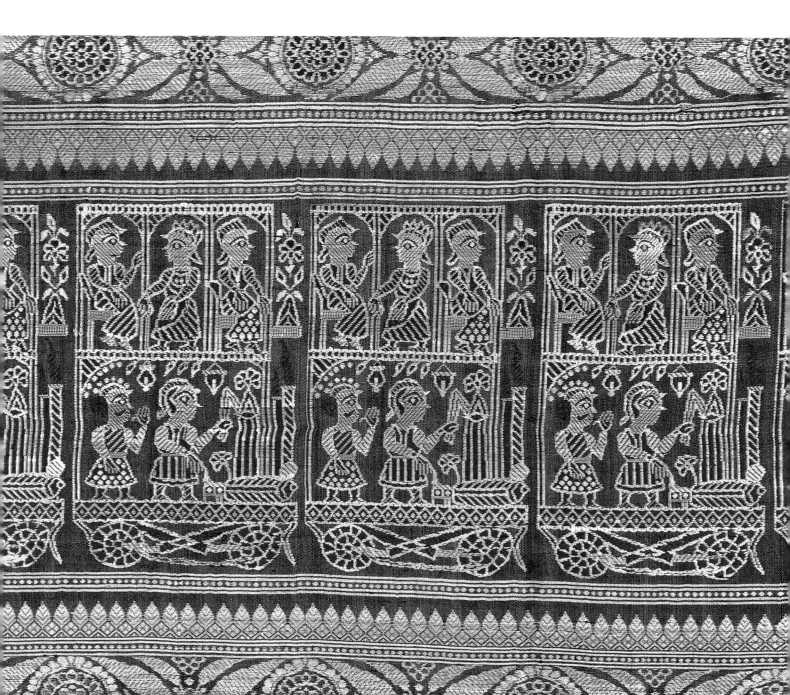

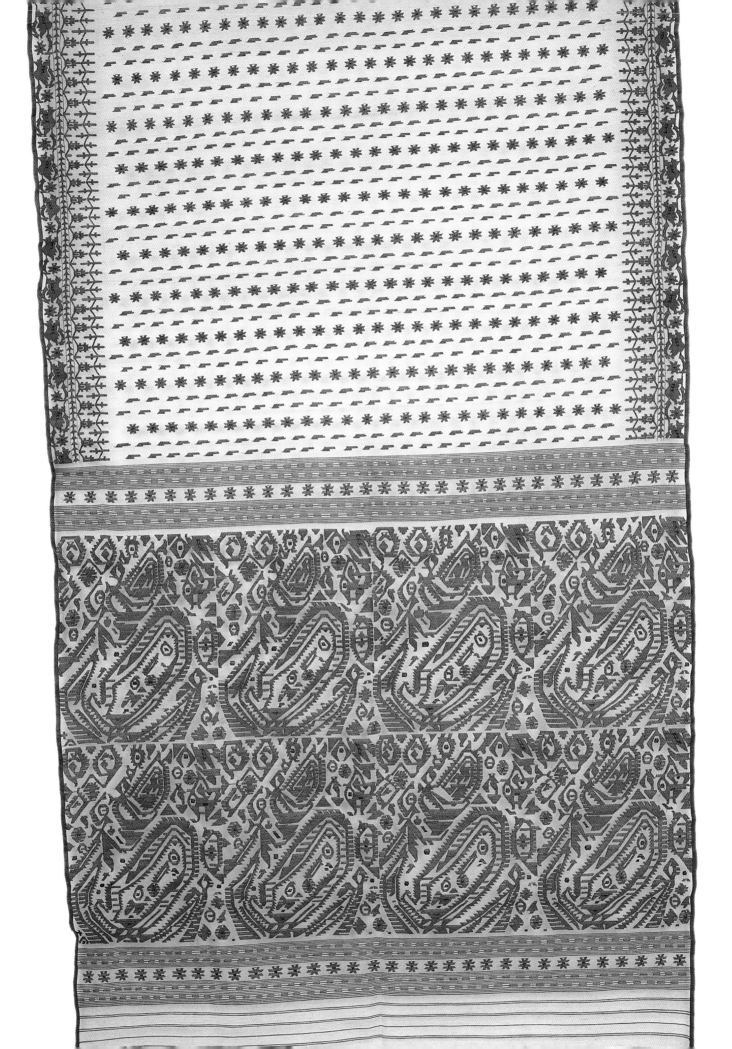

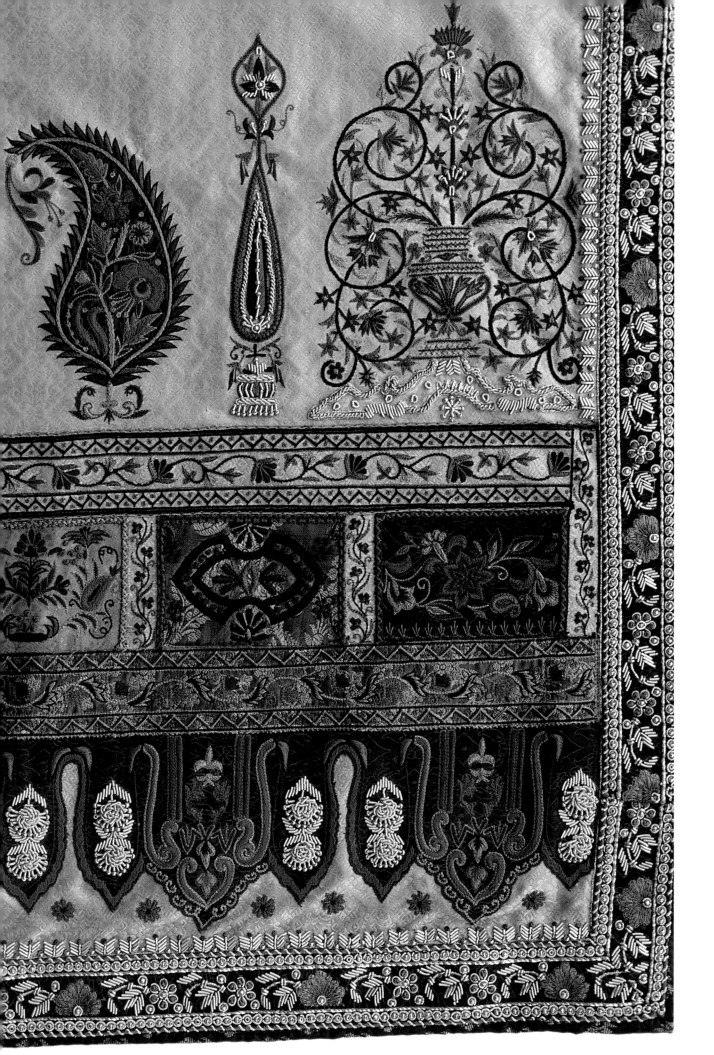

A silk headshawl (*dupatta*) with silk embroidery and gold work (*zardozi*), which has derived its ornamentation from the pattern of a nineteenth-century Kashmir shawl. Karachi, Sindh, 1999. Collection Banto Kazmi

SHAWLS AND HEAD COVERINGS

The term shawl, which may originally have been used to describe a type of woven textile, is now a generic term for a length of cloth draped over the head and around the shoulders and worn by both men and women.

Shawls made of cotton, silk or wool are seen in great variety in South Asia. They may be unadorned lengths of coarse, often domestically woven, cloth, striped, plaid or plain, with contrasting borders. Further decoration may take the form of tie-dyeing the cloth, printing, embroidery or the addition of small ornaments. Rural production may occur in small weaving towns and villages, while more elaborate versions are produced in factories and commercial workshops. Here, classical Mughal floral patterns and Kashmir shawls, among a number of other design sources, provide inspiration for complex designs that are continually being adapted to suit contemporary urban taste (fig. 21).

The Kashmir shawl represents the best-documented textile tradition of South Asia, dating back to seventeenth-century accounts by European travellers. The fine *pashmina* and *shah tus* shawls of Kashmir are very well known. *Shah tus* is made of wool from the soft underbelly of the Tibetan goat (*Capra hircus*), which is found at high altitudes. Women spin the fleece into fine yarn and men are responsible for weaving it into shawls of subtle colours ranging from beige and cream to beautiful browns and greys. These fine wools may be woven with silk thread and occasionally dyed to produce brighter shades. Shawls woven with ornate floral and paisley patterns, which have earned Kashmir a special place in textile history, are known as *kani*. In addition to elaborate woven patterns, the ground fabric may also be embroidered to produce *amli* shawls. Exquisite samples dating from the seventeenth to the nineteenth century

demonstrate that Kashmir shawls were put to a number of uses – as waistbands and turban cloths as well as shoulder mantles. Weaving in Kashmir tends to be a seasonal activity; farmers resort to weaving in the winters, producing thick woollen shawls or *chadars*. Nomadic shepherds and gypsies carry *chadars* over their shoulders all through the year (see The Paisley Shawl).

In the desert areas of Sindh, Kutch and western Rajasthan, women's shawls (*odhani*) in daily use are skilfully decorated. Lavishly embroidered patterns with their attendant symbolism are especially reserved for shawls as dowry gifts (*abochhini*). For most of the herding groups, woven wool shawls for men, (*dhabro, dhablo* or *khato*) and embroidered shawls for women (*odhani*) with patterns of peacocks, fish, scorpions, flowering shrubs, temples, mounds and geometric motifs drawn from nature, are both markers of group identity and are endowed with safeguarding qualities. Muslim groups favour floral and non-figurative patterns with mirrors as a major decorative element. Tie-dyed (*bandhani*) shawls are popular throughout Sindh, the Cholistan desert belt of Punjab and Rajasthan. Patterns vary in complexity from scattered single dots to medallions and floral and figurative motifs (figs. 22–24, 26).

In many parts of the subcontinent covering the head and body is synonymous with modesty and virtue in women. Men, too, wear shawls over their shoulders or occasionally wrap them around their heads as turbans with one end hanging down. Of these, the large resist-printed textile known as the *ajrak* is the most popular shawl for men and, increasingly, for women in Sindh. *Ajraks* have traditionally been associated with the lower Indus valley, Kutch, Gujarat and Rajasthan. In Sindh in particular, an *ajrak* is printed on both sides of the cloth (*bepassi*) whereas in Kutch and Gujarat it is printed on one side only (*hikpassi*; fig. 27). Other

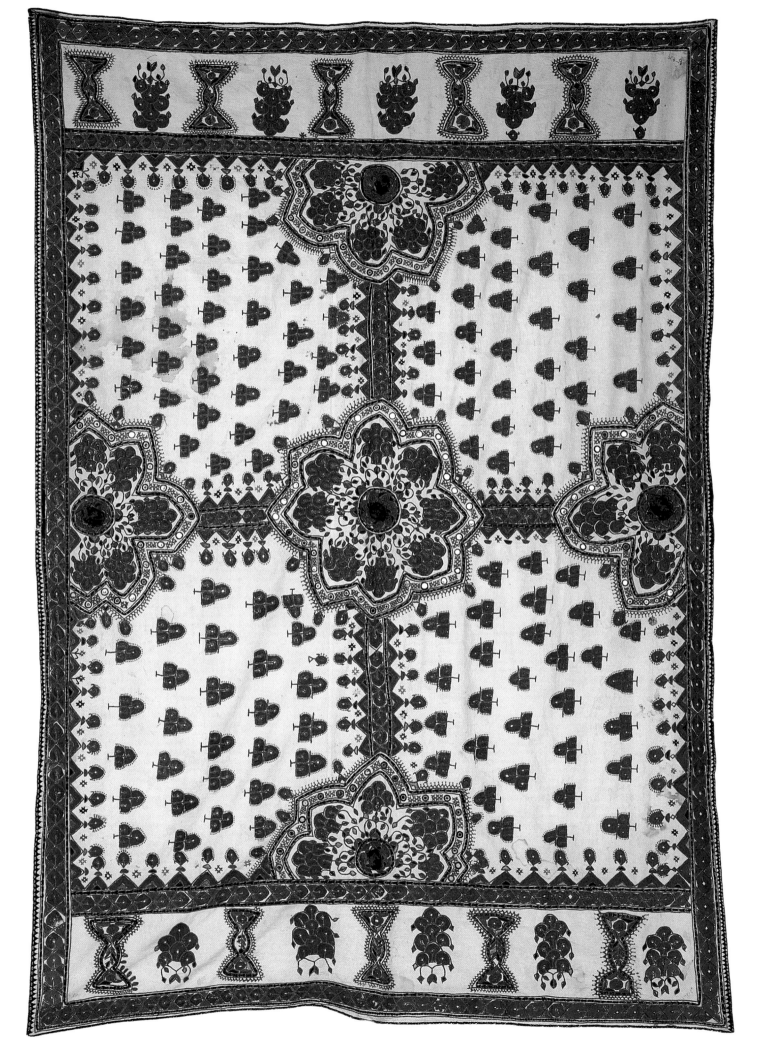

22 FACING PAGE

Woman's shawl (*abochhini*)

Sammat groups, Mohrano or Tharparkar, Sindh

Early 20th century

Cotton embroidered with silk, applied mirrors and tassels

L: 213 cm W: 154 cm

This type of embroidered *abochhini* is distinctive of Sammat groups all over the desert areas of Sindh. The stylized floral motifs seen here are the buds and blossoms of the *akk phuli* shrub (*Calotropia procera*) and are most frequently found on bridal shawls of Muslim families.

23 ABOVE

Woman's shawl (*abochhini*), detail. Probably Memon group, Kadhan, Badin, Indus delta. Mid 20th century. Cotton embroidered with silk. L: 200 cm W: 135 cm

This shawl has been embroidered in a traditional *kacho* or *soof* style using surface darning stitches in a thread-counting technique. The *soof* style is characterized by its fine, linear and geometric motifs.

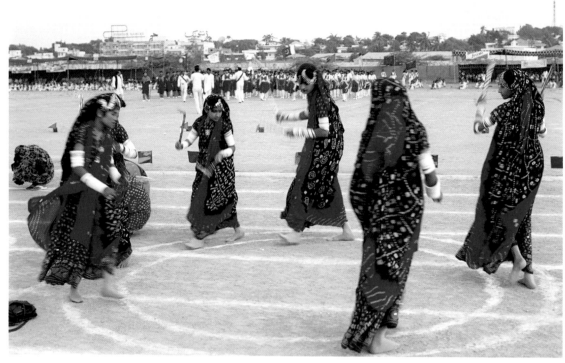

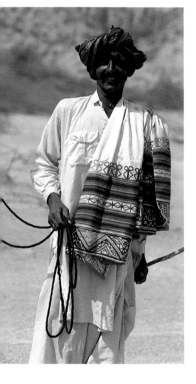

resist-printed cotton shawls using a simpler
technique of wood-block printing and dyeing,
known as *maleer*, are worn by men and women of
both Hindu and Muslim groups in these areas.
Maleer are usually made of commercially purchased
cotton, dyed deep red, blue or black with repeating
floral and geometric motifs in the field and multiple
borders.

Meghwar groups embroider *maleer* for their
bridegrooms. These are densely embroidered in a
distinctive *pakkoh* style of embroidery at both ends
and at the four corners. Motifs include stylized
renditions of peacocks and the flowers that bloom
in the desert following the monsoon. The textile
may also be wound as a turban around the
bridegroom's head or as a shawl for the newly
weds during the wedding ceremony. A long narrow
scarf or sash, the *bokano* (literally 'two ears')
embroidered with peacocks, flowers and mirrors is
also an important gift for the Meghwar
bridegroom. The *bokano* is worn over his head and
tied under his chin to keep his turban in place on

his wedding day. Occasionally it may be used as a
sash tied around his waist or as a scarf (fig. 31).

Rabari pastoral groups wear woollen
garments and shawls with the most vivid and
abstract patterns. Wedding shawls or veils (*ludi*) are
embroidered in dazzling combinations of motifs
using mirrors (figs. 28–30). As there are strong
cultural and historical affinities between Rabari
groups in Sindh, Kutch, Gujarat and Rajasthan
(fig. 25), they share a number of different styles of
adorning cloth.

The fertile agricultural plains of East and West
Punjab are known for their vibrant folk and urban
textile traditions. *Salara* is a term recently coined to
describe a cotton, silk-and-cotton or woollen shawl
commonly worn by both men and women in the
rural areas. *Salaras* are very attractive with their
plaid and striped fields offset by contrasting edges
and borders often containing serrated or toothed
patterns. A *salara*, or the somewhat smaller *salari*, is
worn by women and woven in pairs of one-and-a
half-metre lengths, which are then stitched together.

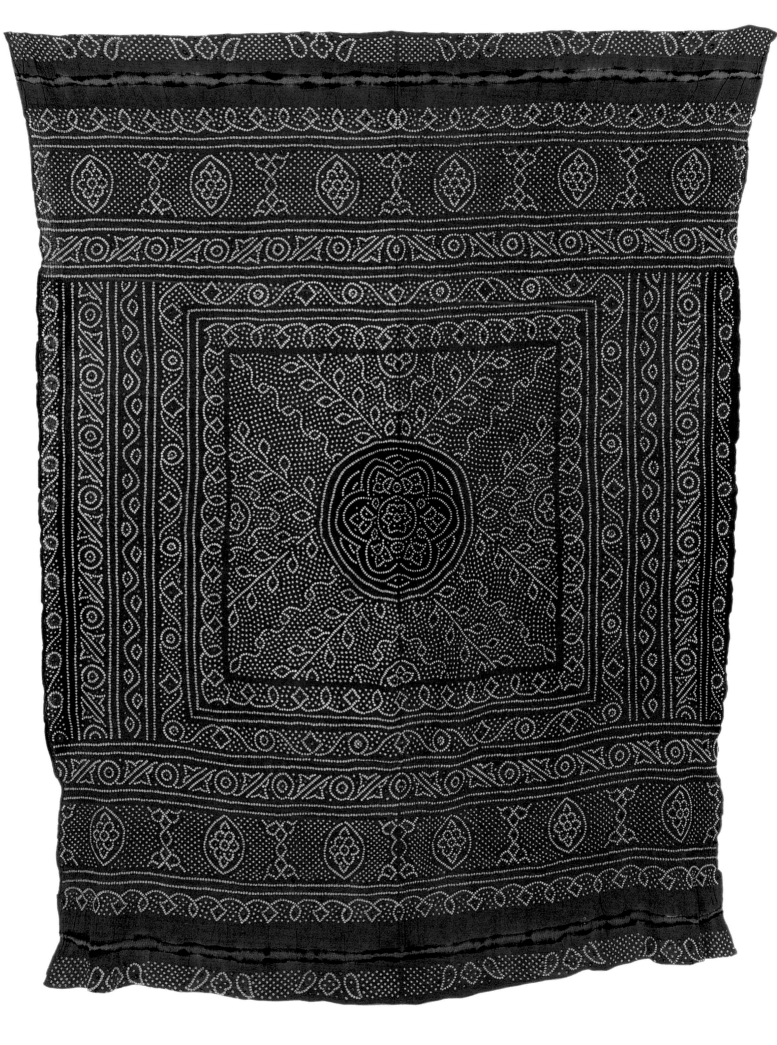

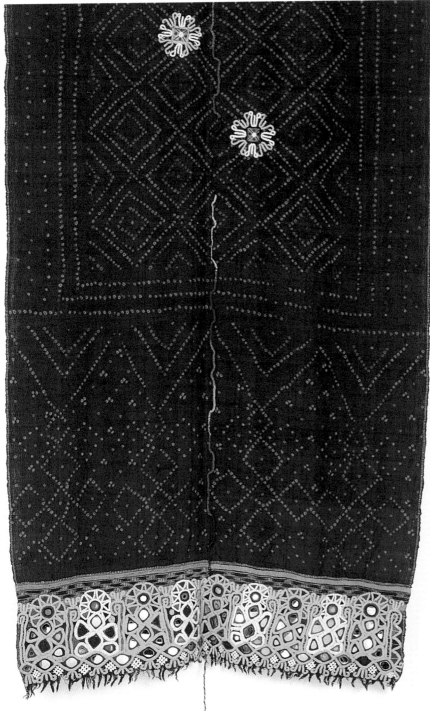

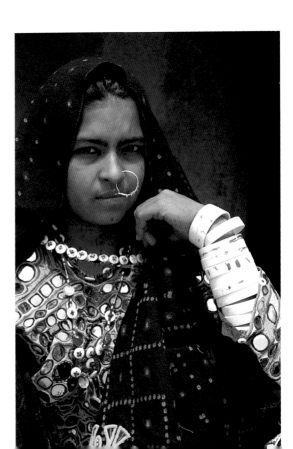

27 FACING PAGE
Man's shawl (ajrak), detail
Matiari, Vicholo, Sindh
20th century
Resist-printed cotton
L: 246 cm W: 172 cm
This resist-printed and mordant-dyed shawl is one of the best-known textile traditions of Sindh. The most common colours are shades of blue and red with the white of the ground fabric showing through. The design seen here is referred to as the cloud pattern (kakkar).

28 ABOVE LEFT
A group of Rabari pilgrims from Ahmedabad at the Jodhpur fort, 1986. The men can be seen wearing traditional turbans, gathered tunics (kediyun) and waistcloths (dhoti) The women are draped in large shawls (ludi), amply gathered skirts (gaghra) and blouses (kanchali).

29 BELOW LEFT
Woman's shawl (ludi)
Kutchi Rabari group, Dano Dandhal, Nagarparkar, Sindh
Mid 20th century
Wool with supplementary weft borders, tie-dyed and embroidered with silk and cotton, applied mirrors
L: 286 cm W: 84 cm
Private collection

30 BELOW
A Rabari girl wearing her wedding shawl (ludi), Kasbo village, Nagarparkar, Tharparkar, 1996

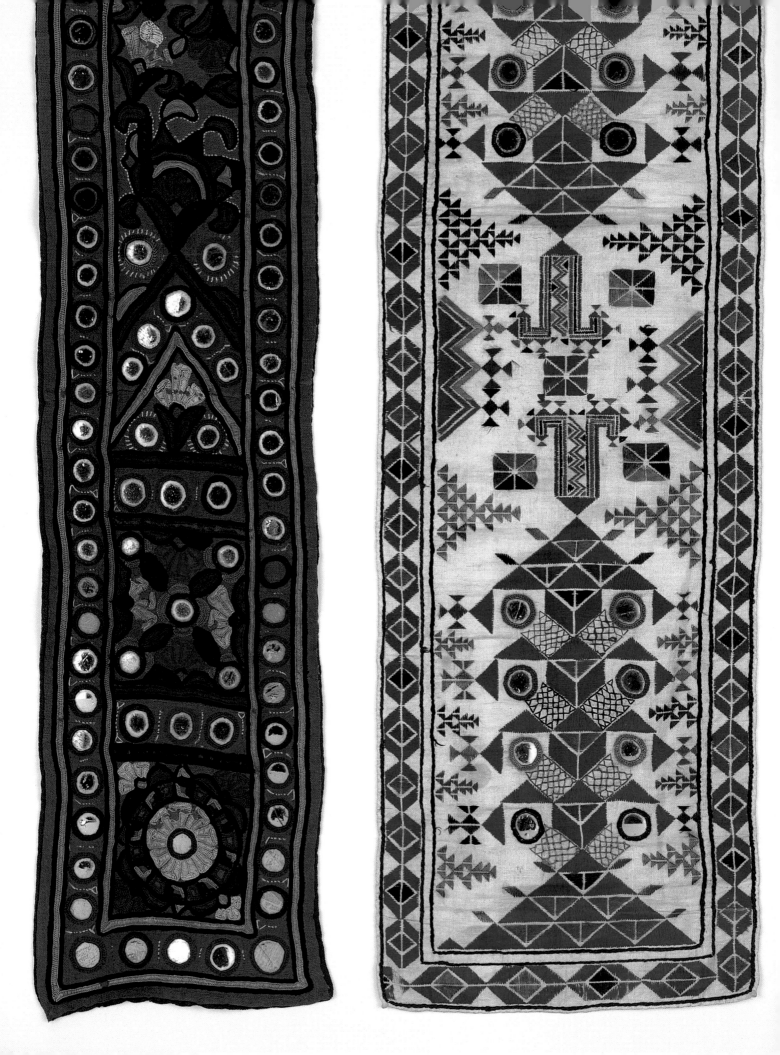

31 FACING PAGE

Man's wedding scarves or
sashes (*bokano*)
Left:
Meghwar group, Diplo,
Tharparkar or Badin,
Indus delta
Mid 20th century
Cotton with silk embroidery,
applied mirrors
L: 165 W: 14 cm
Right:
Suthar group, Umarkot,
Tharparkar, Sindh
Mid 20th century
Cotton with silk embroidery,
applied mirrors
Collection Nasreen Askari
Both these scarves have
embroidered patterns of
stylized peacocks and flowers.
They are worn by Meghwar
and Suthar grooms in a
number of ways: as a
cummerbund or sash, as
a scarf tied under the chin to
keep the turban in place or
around the neck with the
ends thrown back.

32 RIGHT

Woman wearing a shawl
(*salari*), which has had a small
square of mirror-work
embroidery and a border
added to it, features of
contemporary urban fashion,
Karachi, Sindh, 1991

33 FAR RIGHT

Man wearing a *salara* shawl,
Sargodha, Punjab, 1999

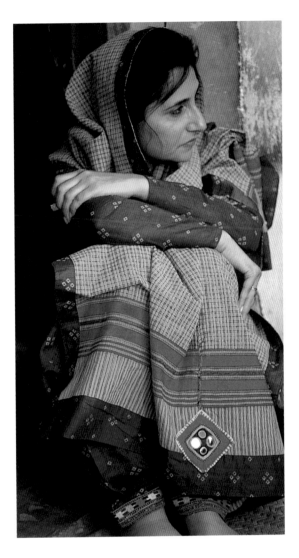

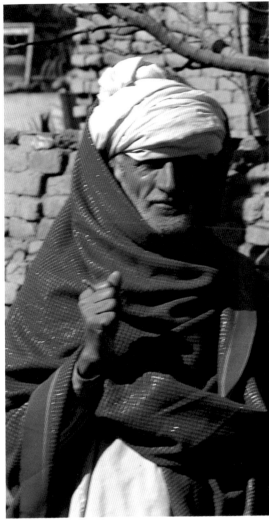

Salaras are woven on traditional pit as well as power looms in a number of towns in West Punjab, particularly Mianwali, Campbellpur, Khushab, Kamalia and Jhang (figs. 32, 33).

Shawls known as *phulkari* are the best known of the Punjab's rural embroidery traditions. These consist of stylized floral patterns embroidered in floss silk on coarse cotton dyed brown, blue or red. The floss silk is generally white, orange or yellow with accents in bright pink, green and purple (figs. 34, 35). The finest *phulkari*, known as a *bagh* or garden, is embroidered as a trousseau or dowry gift, very often so densely that the ground fabric is barely visible. Among a number of traditional farming groups, *phulkaris* were exchanged between

the bride and groom's families for the rituals of the wedding ceremony and for festive wear on social occasions. *Phulkari* is a term often loosely used to describe a shawl with a floral pattern but more accurately describes a shawl embroidered in floss silk in repeating geometric motifs, usually in a stylized floral form.

The *phulkari* tradition extends beyond the Punjab to the Swat valley and the tribal belt of the North West Frontier in Pakistan. The Hazara plains that lead up from the Punjab to the Karakorum mountains and the adjoining Swat valley up to the Hindu Kush range show interesting variations in the *phulkari* style. Bright pink and red floss-silk embroidery is employed on white or indigo-blue

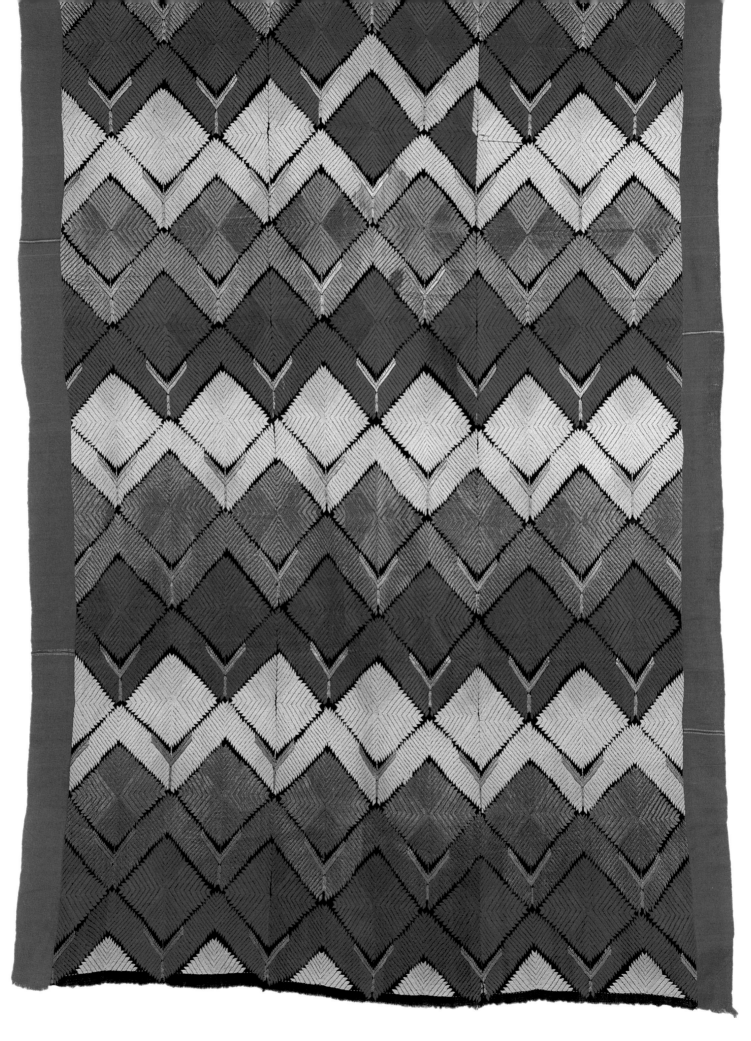

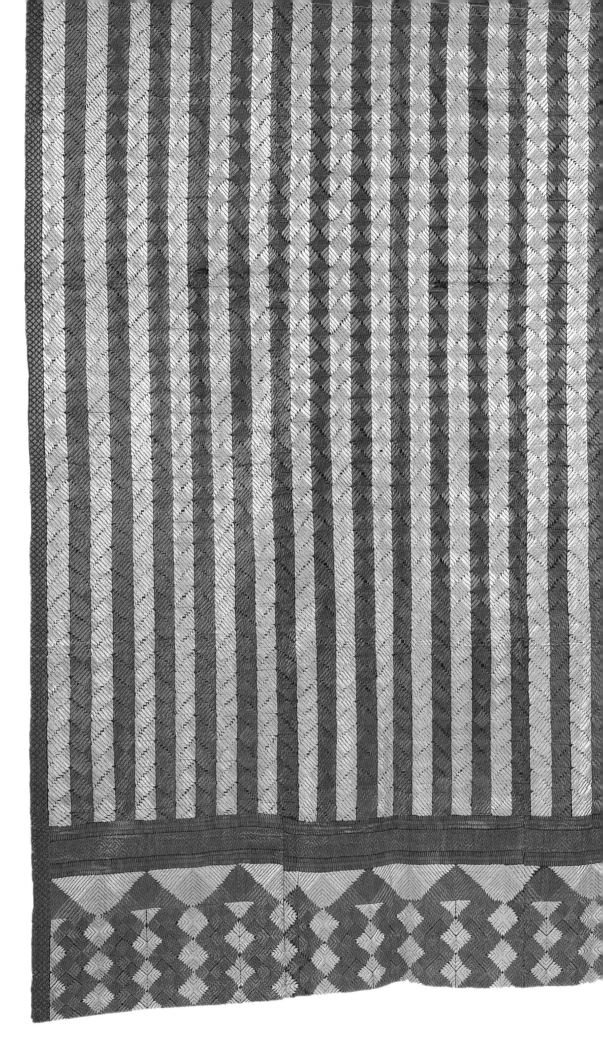

34 FACING PAGE
Woman's shawl (*phulkari*),
detail
Punjab, Pakistan
Mid 20th century
Cotton embroidered with
floss silk
L: 240 cm W: 130 cm
Collection Shehnaz Ismail
This *phulkari* is an exuberant
example of wedding shawls
found in the Punjab. Fine
surface darning stiches ensure
that the shawl can often be
entirely embroidered from the
reverse side and very little of
the floss silk is visible on this
side.

35 RIGHT
Woman's shawl (*phulkari*),
detail
Punjab, Pakistan
Cotton embroidered with
floss silk
Mid 20th century
L: 250 cm W: 138 cm
Collection Shehnaz Ismail

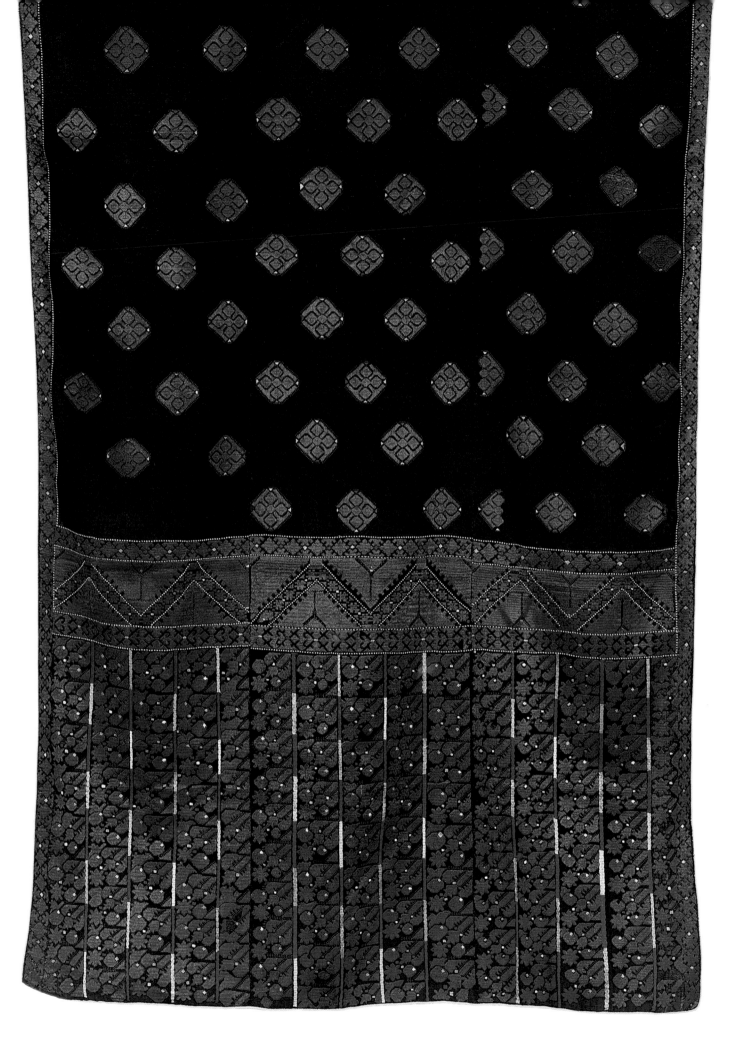

36
Woman's shawl (*phulkari*),
detail
Swat valley, North West
Frontier
Mid 20th century
Cotton embroidered with
floss silk
L: 214 cm W: 102 cm
Collection Shehnaz Ismail

cotton fields using geometric motifs that are less rigid than those of the Punjab. *Phulkari* embroidery from Hazara and Swat tends to be in the form of repeating medallions, diamonds and rams' horn outlines, recalling motifs commonly seen in Central Asian textiles (figs. 36, 37, 39, 41). In Waziristan, along the north-western border of Pakistan adjoining Afghanistan, a number of tribal groups weave dramatic cotton shawls with unadorned dark fields and brilliantly coloured silk ends and borders (fig. 40). Throughout the North West Frontier, plain lightweight woollen shawls worn by Pathan tribesmen, in a variety of colours, are a common sight in the bazaars. These are woven on power looms in centres located in Swat, Mansehra and around the capital, Peshawar, and enjoy a variety of local names such as *shari, doosa* and *kambal* (figs. 42, 43).

In Makran, the coastal belt of Baluchistan, a densely woven cloth called *patti,* of sheep's wool, is made up into shawls worn by nomadic groups who migrate seasonally from the upper reaches of the central hills and plateaux (fig. 44). Woollen shawls are often adorned with floral patterns using silk thread. Baluchi embroidery is striking in its colourful geometric compositions using satin stitches and a thread-counting technique in the ground fabric. Baluchi women wear enveloping shawls (*suri*) over loose ankle-length tunics (*pashk*) and gathered trousers (*shalwar,* fig. 45).

Banaras, with its reputation for elaborate silk weaves using metal threads (*zari*), is the centre for ceremonial headshawls (*dupattas*). Traditional Banarsi brocades are woven with silk and silver- or gold-wrapped wefts to create beautiful patterns (fig. 47). Banarsi weaves vary tremendously as professional weavers create different textiles to suit regional tastes and changing fashions. When gold and silver threads are used together in the same length, often in alternating bands, the brocade is called a *ganga jamna,* after the two great rivers of the plains. In Bengal, a similar distinctive weave, primarily using fine cotton warp and often *zari* thread as an extra weft, is referred to as *jamdaani* (figured muslin). The *jamdaani* technique is popularly used for traditional *dupattas* and saris (see pp. 30–36 above). Here and in the neighbouring state of Orissa, local *tassar* silk provides yarn for *ikat* dyed shawls and shoulder cloths.

Woollen cloth is an important material for costume, especially for shawls, in the mountainous northern reaches of the subcontinent. In Arunachal Pradesh, Mishimi women weave lengths that are skilfully attached to each other with decorated strips to make up waistcoats and jackets. In Kulu and Manali, in the western Himalayas, woollen cloth (*patti*) is used for garments and for large women's shawls with borders referred to as *pattu.* These may have plain or plaid fields with multicoloured geometric motifs in their borders, woven in an interlocking technique (figs. 38, 46).

Strong weaving traditions exist in Nagaland, Mizoram, Tripura, Assam and Manipur on the north-eastern borders of the subcontinent. Women of the hill tribes weave on traditional backstrap looms, each tribe having its own favourite patterns for shawls and ritual garments, generally in black, brown, white, red and green. The Tangkul Naga shawl of Manipur is a thick cotton shawl worn by men and woven by women in striking bands of rust and black. The bands may vary in width and the ends of the shawl are often decorated with brilliantly coloured extra wefts (figs. 48, 49). In Tripura, young girls of the Riang tribe wear cotton breastcloths (*riah*) woven with coloured stripes in a supplementary warp technique. These are reputedly imbued with sacred protective qualities (fig. 50).

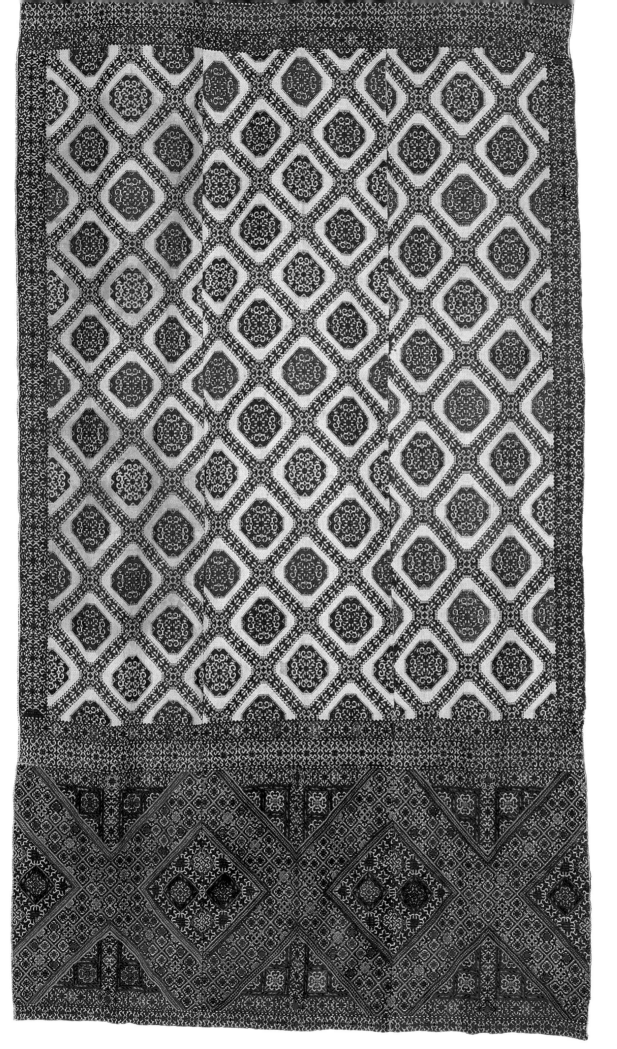

37 LEFT
Woman's shawl (*phulkari*),
detail
Balakot, Hazara, North West
Frontier
Mid 20th century
Cotton embroidered with
floss silk
L: 225 cm W: 106 cm
Collection Nasreen Askari

38 FACING PAGE
Shawl (*pattu*), detail
Himachal Pradash
20th century
Sheep's wool
L: 240 cm W: 119 cm
Collection Sarah Sumsion

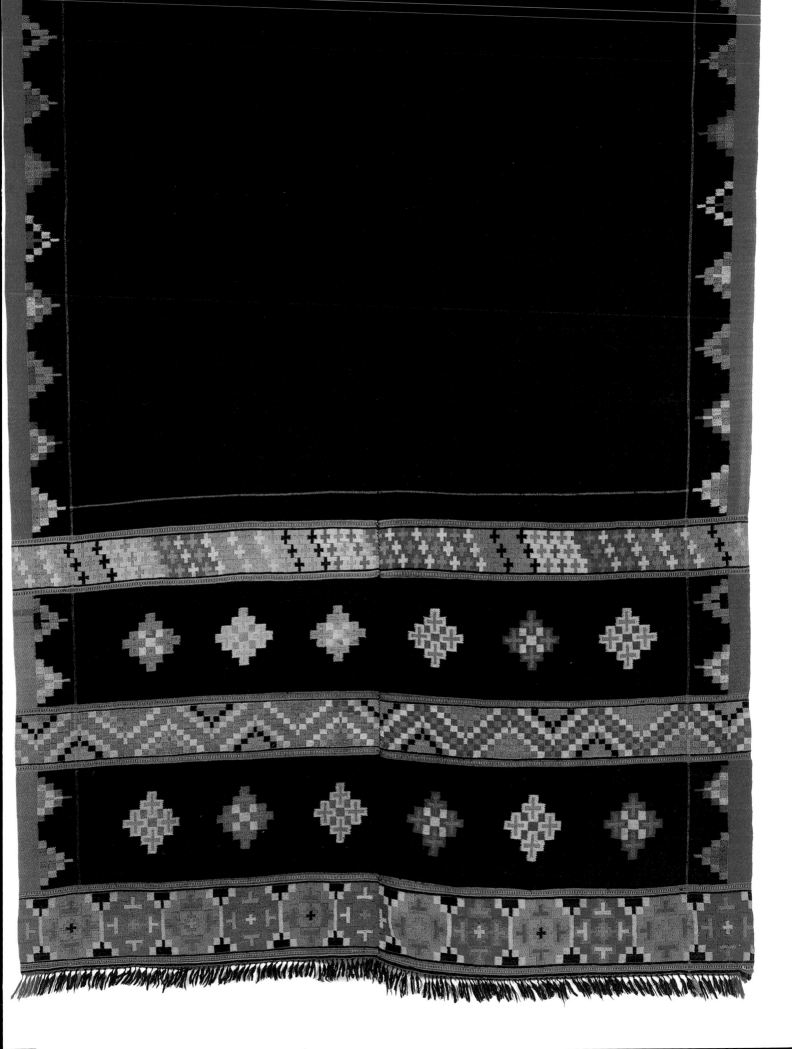

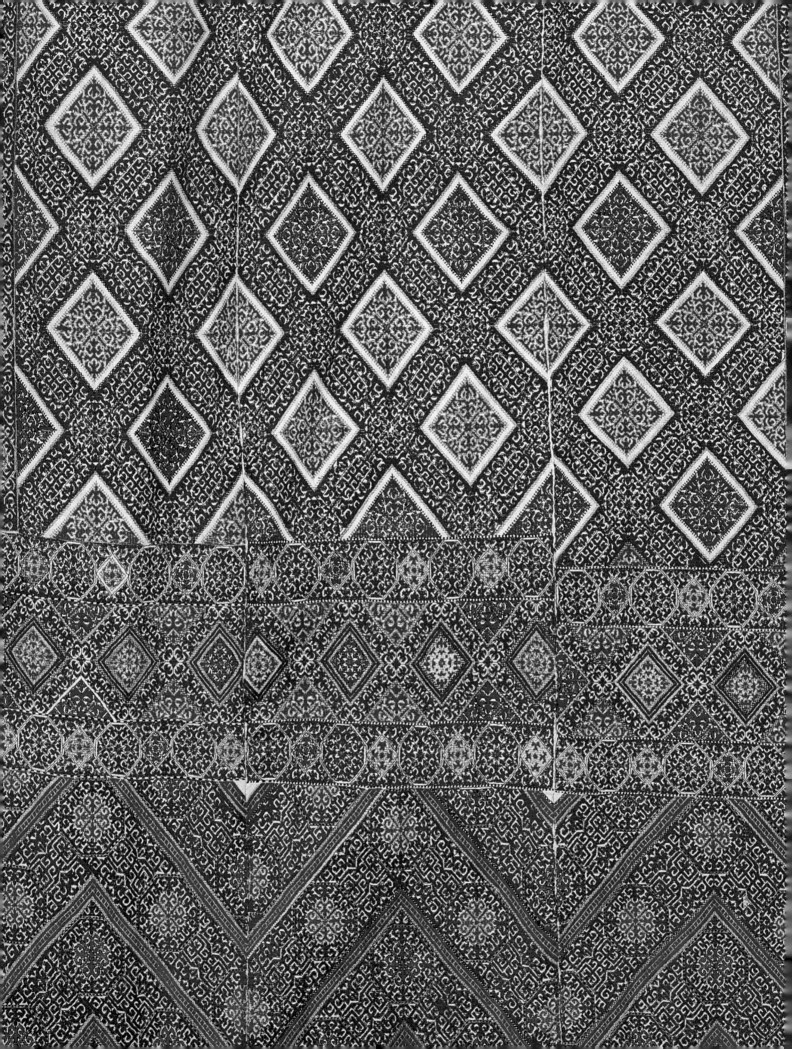

39 FACING PAGE
Woman's shawl (*phulkari*),
detail
Mansehra, Hazara, North West
Frontier
Mid 20th century
Cotton embroidered with
floss silk
L: 230 cm W: 110 cm
Private collection

40 RIGHT
Woman's shawl (*chadar*), detail
Waziristan, North West
Frontier
Mid 20th century
Woven cotton with silk ends
and borders
L: 232 cm W: 102 cm
Collection Nasreen Askari

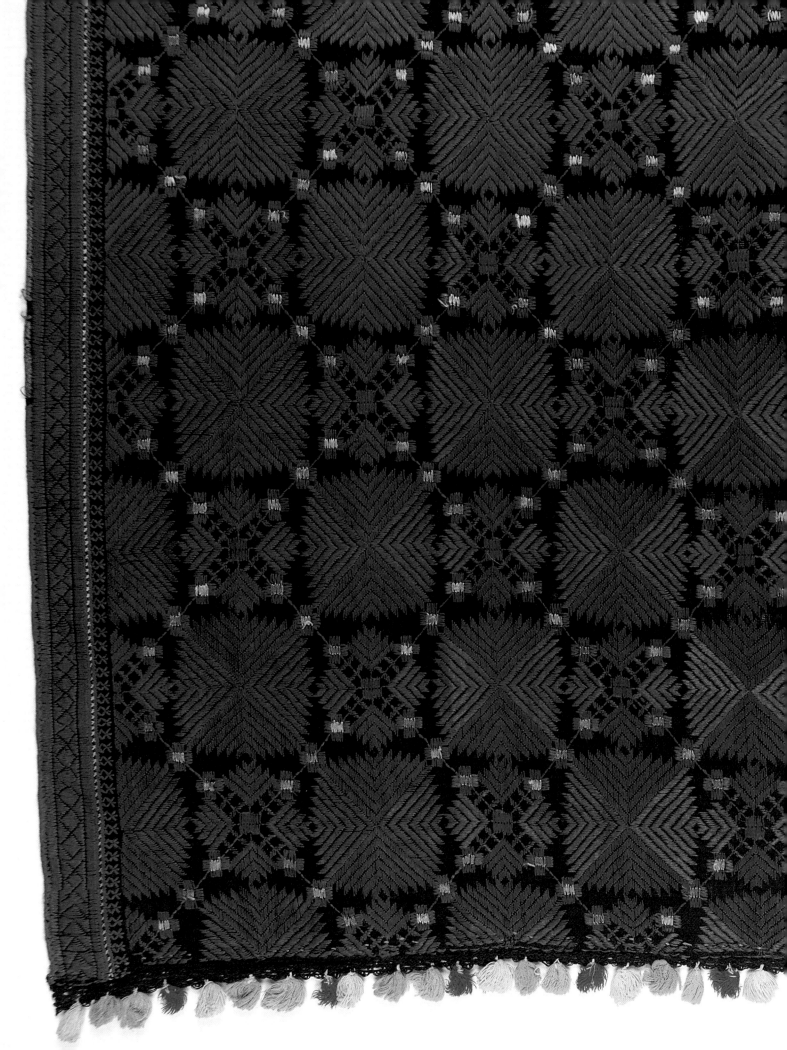

42 ABOVE LEFT
Pathan men wearing *kambal*
shawls, Peshawar bazaar, 1998

43 ABOVE RIGHT
A father and son wearing *shari*
shawls, Islamabad, 1999

41 FACING PAGE
Woman's shawl (*phulkari*),
detail
Kalam, Swat Valley, North West
Frontier
Early 20th century
Cotton embroidered with
floss silk
L: 270 cm W: 100 cm
Collection Nasreen Askari

44 LEFT
Length of woollen cloth (*patti*),
detail
Makran, Baluchistan
1995
Left: L: 444 cm W: 37 cm
Right: L: 186 cm W: 36 cm
Private collection

45 RIGHT
Woman's shawl (*chadar*), detail
Kalat, Baluchistan
Mid 20th century
Cotton embroidered with silk
L: 280 cm W: 130 cm
Private collection
The satin-stitch embroidery on
this shawl, although not very
fine, is typical of the style and
colours found in the mountains
and hills of central Baluchistan.

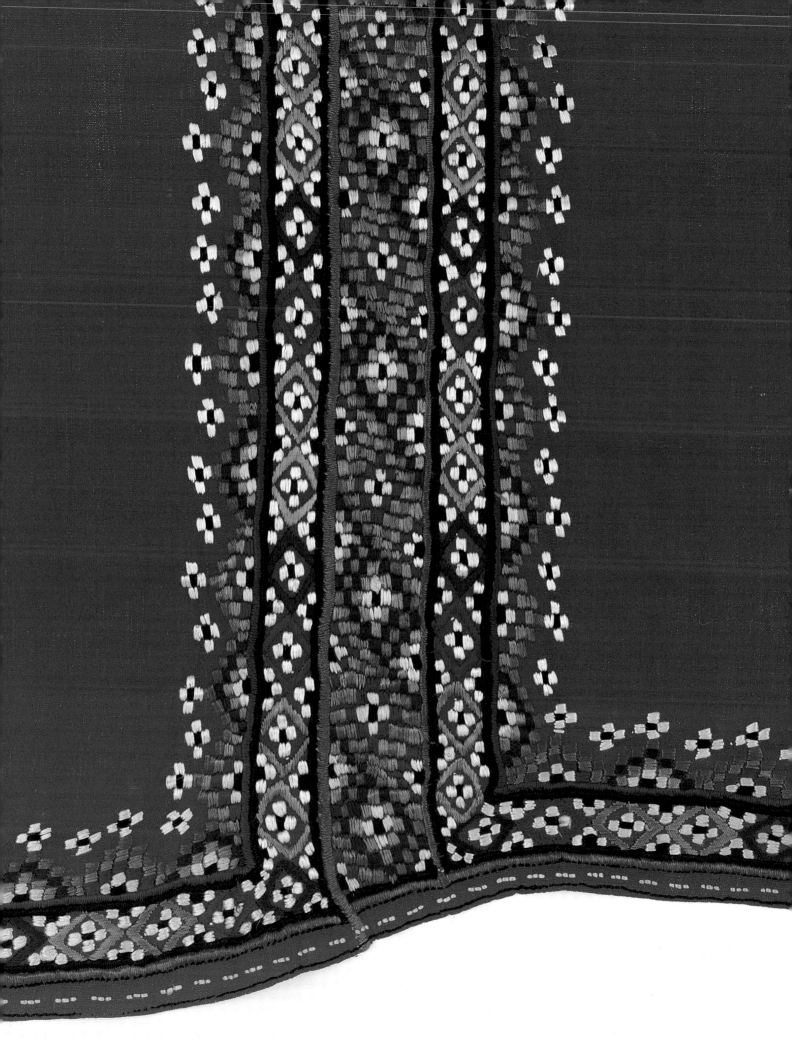

46 LEFT
Woman's shawl (*pattu*), detail
Kulu, Himachal Pradesh
20th century
Woven wool
L: 294 cm W:117 cm
Collection Sarah Sumsion

47 FACING PAGE
Headshawl (*dupatta*), detail
Banaras, Uttar Pradesh
Late 19th century
Silk woven with gold thread
L: 256 cm W: 152 cm
Collection Joss Graham

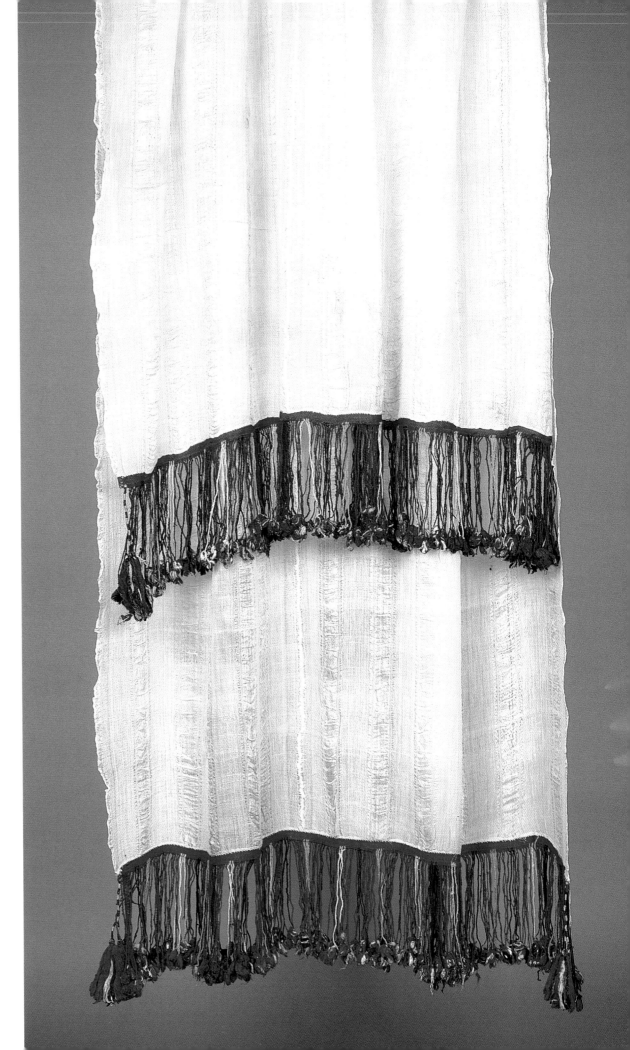

48 FACING PAGE
Man's shawl, detail
Tangkhul Naga, Manipur
20th century
Woven cotton
L: 243 cm W: 120 cm
Collection Jasleen Dhamija
White and green extra wefts at
the ends of the shawl create a
luminous pattern in contrast to
the field.

49 RIGHT
Woman's shawl, detail
Assam
Late 19th century
Silk with silk edging and tassels
L: 243 cm W: 120 cm
Glasgow Museums, Eth/NN/18

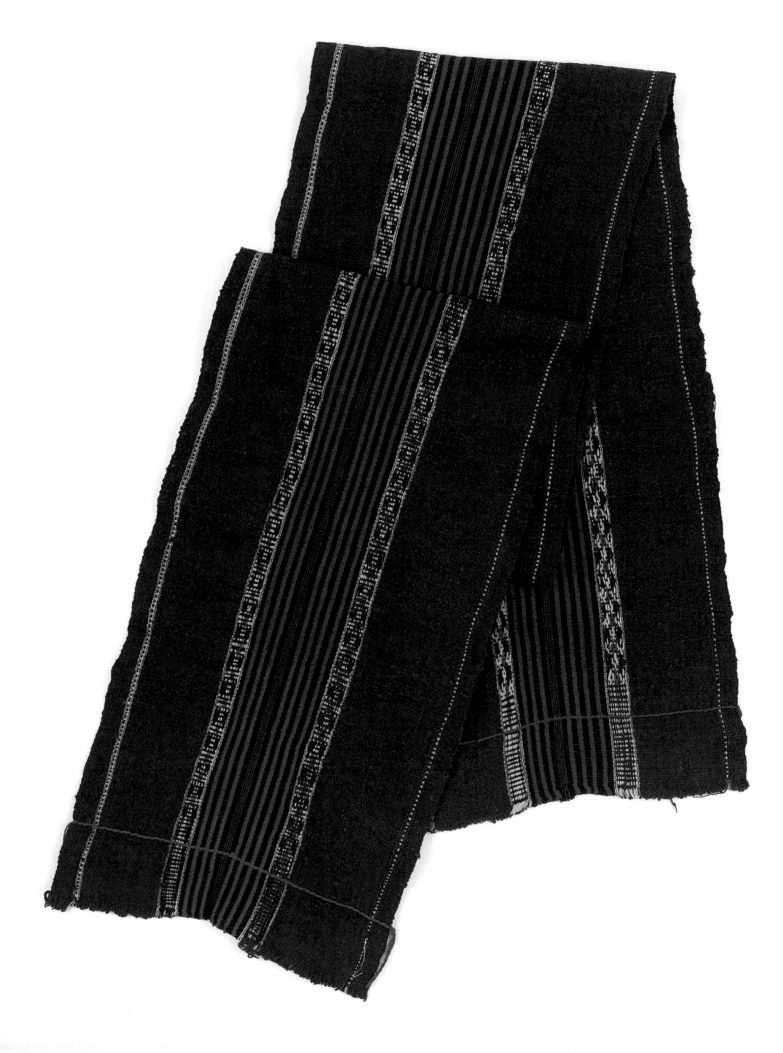

TURBANS

Headgear is an important part of male costume in India and Pakistan. Generally worn outdoors, a turban (*pag*, *patka* or *paghri*) on a man's head signifies honour, respect and authority for his person (just as a shawl or covering on a woman's head is equated with modesty and virtue).

The varied types of uncut cloth used as headgear display the identity and origin of the wearer. Caste, class and profession can be revealed in the pattern, forms and tying modes of the turban. The brightly dyed, block-printed turban cloths of Rajasthan, Sindh and Punjab are also referred to as *safa*. Sumptuously woven cloths using silk and gold threads (*lungis*) are generally worn for more formal or ceremonial occasions in Sindh and Baluchistan (figs. 51–53).

In the northern areas of Pakistan, influenced by neighbouring Iran, Afghanistan and Central Asia, Pathan tribesmen wrap long turban cloths around their heads, over soft caps (*topi*) or stiff embroidered caps (*kulah*). One end is often left loose over the shoulder and may function as a face-cloth. The form of the *kulah*, the length of the turban, its colour and its wrapping method help distinguish between different Pathan and Afghan groups (although this differentiation is now becoming less marked). Synthetic silk thread is commonly used to weave turban cloths for formal wear (*mashhadi*; figs. 54, 55), and popular colours include yellow, brown, grey and blue with dark end-borders. Turbans, which are mandatory for Sikhs, had regional variations; these have since given way to a more standard form in which five to six metres of pleated and starched muslin is used.

The intricately tie-dyed turbans of the Rajasthan desert areas have very striking striped or zigzag patterns called *leheriya* (waves). The technique employed is a wrap resist-dyeing method. The cloth is rolled, tied at intervals and dipped in dye, which then penetrates the areas that have not been tied. Different tie-dyed patterns are synonymous with different areas and often with different occasions. The *leheriya* are especially worn in the monsoon season, the *panchrang* (five-colour) is for festive wear, while the *bundi* (small-dot) pattern and the *mothro* (small squares), in austere colours, are reserved for more sombre occasions (fig. 58). Some groups may have their turban cloths woven or stamped with decorative gold ends. In Kutch, bright red-coloured tie-dyed cotton turbans are regarded as auspicious. In Sindh and Rajasthan *ajrak* is also a popular turban cloth. It is commonly red and blue with resist-dyed patterns. A Sindhi turban does not consist of a continuous fold wrapped around the head as in the Rajasthani style, but is twisted, divided into two segments by a crossband formed by one of the ends and then tied diagonally across the head (figs. 60–62). The

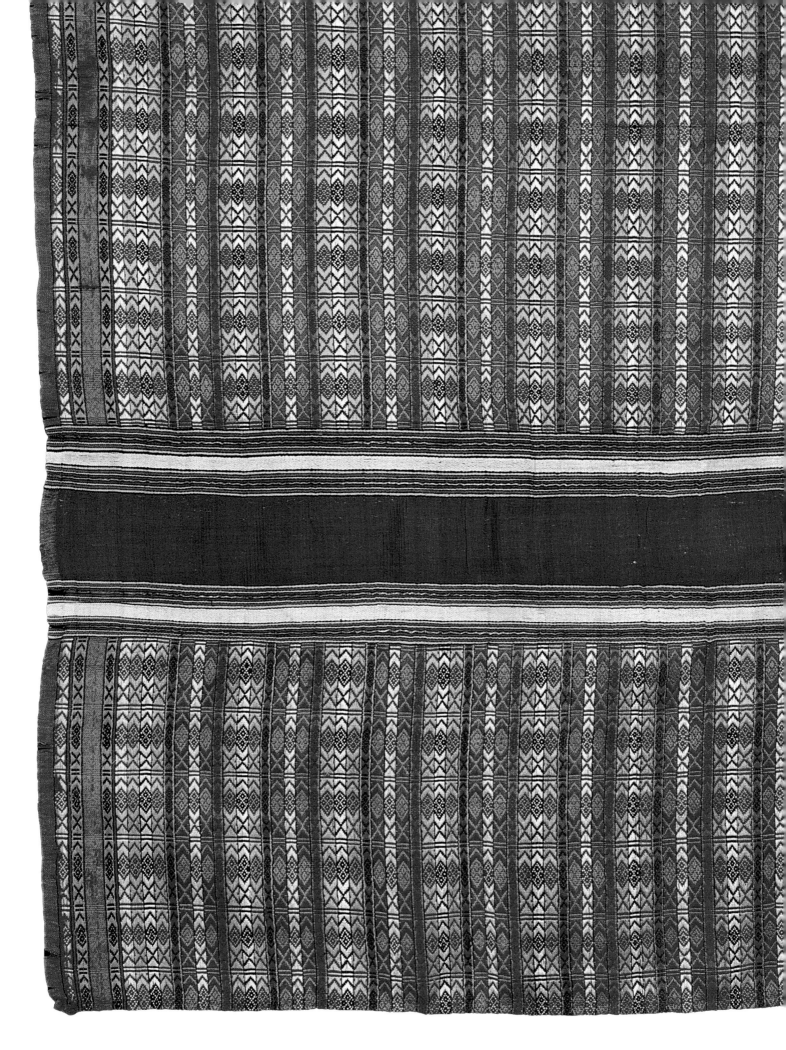

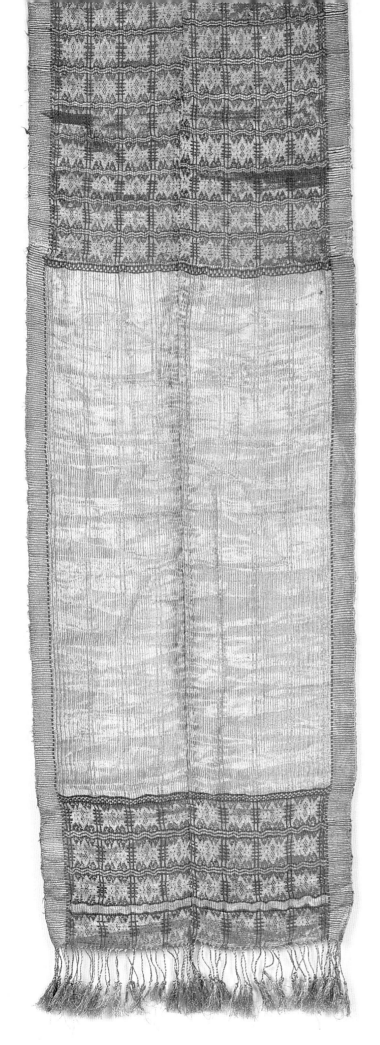

other end of the turban may be pulled away from the centre and pleated into an upright fan-like shape known as a *turro*. (The term *lungi* in Punjab, Bangladesh and southern and central India generally refers to a waistcloth but in Sindh and Baluchistan it is a turban cloth or sash; figs. 51–53).

52 FACING PAGE
Man's turban cloth or sash (*lungi*), detail
Thatta, Sindh
Mid to late 19th century
Woven silk
L: 248 cm W:135 cm
Sindh Provincial Museum, Hyderabad
Lungis are often woven entirely with silk or silk and cotton; silver- and gold-wrapped threads may be incorporated for wear on more formal occasions.

53 LEFT
Man's turban cloth or sash (*lungi*), detail
Kalat, Baluchistan
Early 20th century
Silk woven with gold thread
L: 650 cm W: 44 cm
Attributed to the collection of the late Khan of Kalat, Mir Ahmed Yar Khan
This magnificent *lungi* was a gift from Mir Ahmed Yar Khan's son, Mir Mohammed Dawood Khan, to musician Akhtar Channal Zehri on his performance at Jashn-e-Kalat, Kalat, 1995.

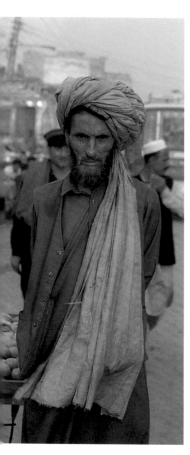

54 ABOVE LEFT
A Pathan wearing a silk turban, Islamabad, 1999

55 ABOVE RIGHT
A *Mashhadi* turban tied on a gold-thread embroidered cap (*kulah*), Islamabad, 1999

56 RIGHT
Headcloth (*Rumal-e-Hajj*), detail
Probably Bengal
Early 20th century
Cotton woven with silk
L: 132 cm W: 132 cm
Collection Jasleen Dhamija
The ground fabric of this headcloth for Muslim pilgrims has been woven with cotton and *muga* silk in the characteristic checked pattern of a *rumal*, with a check field and a plain border all around. Squares, bands and stylized flowers have subsequently been embroidered in silk thread to highlight the woven pattern.

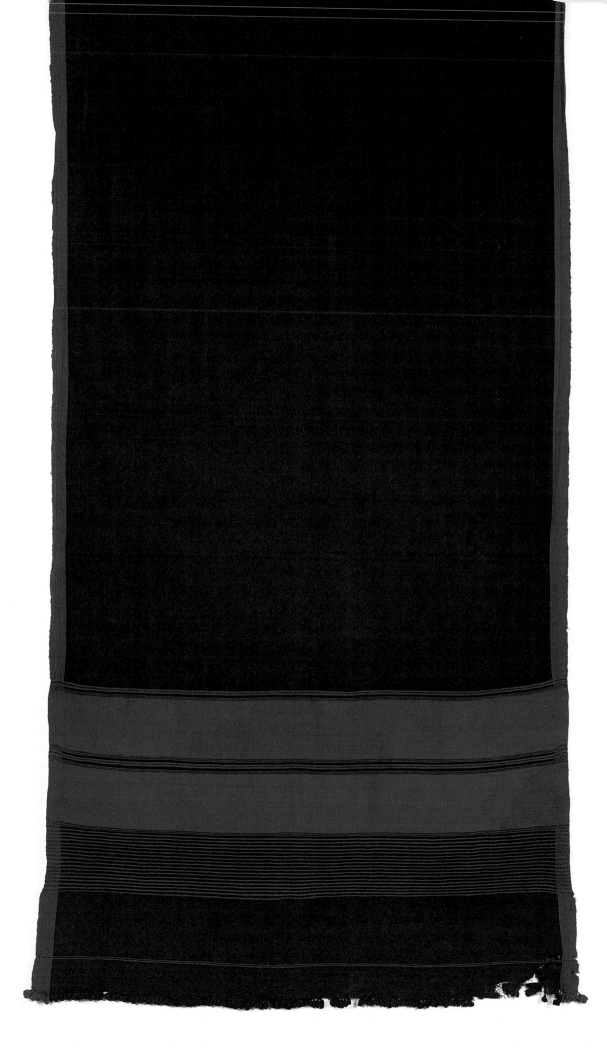

57 RIGHT
Man's turban cloth (*pag*), detail
Thal, Waziristan, North West
Frontier
Mid 20th century
Cotton woven with silk end
borders
L: 496 cm W: 63 cm
Collection Nasreen Askari

58 FOLLOWING PAGES, LEFT
Turban cloths (*pag* or *paghri*)
Left:
Cotton, wrap resist-dyed in a
wave pattern (*leheriya*)
Collection Jayne Sanderson
Middle:
Cotton, wrap resist-dyed on
two diagonals (*mothara*)
Collection Jayne Sanderson
Right:
Tie-dyed cotton (*bandhani*)
20th century
Collection Joss Graham
Below:
Cotton, wrap resist-dyed in a
wave pattern (*leheriya*) in the
untied state
Jaipur, Rajasthan
Late 20th century
Collection Jayne Sanderson

59 FOLLOWING PAGES, RIGHT
Man's turban cloth or sash
(*patka*), detail
Probably Banaras, Uttar
Pradesh
Late 19th century
Silk woven with gold thread
W: 73 cm
Glasgow Museums, 88.109 bc

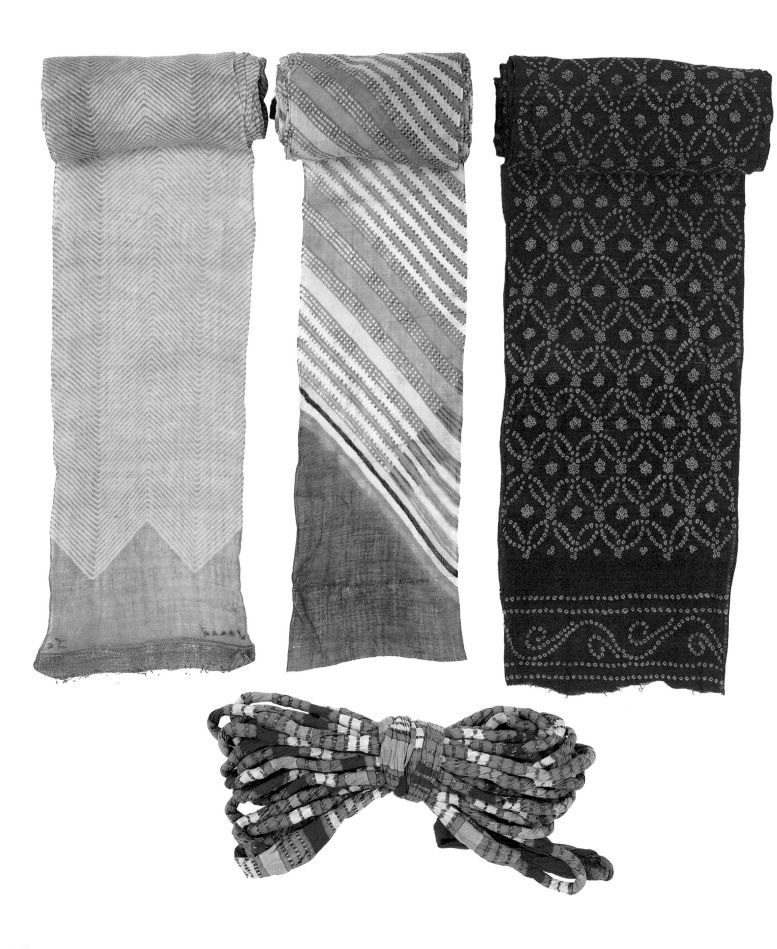

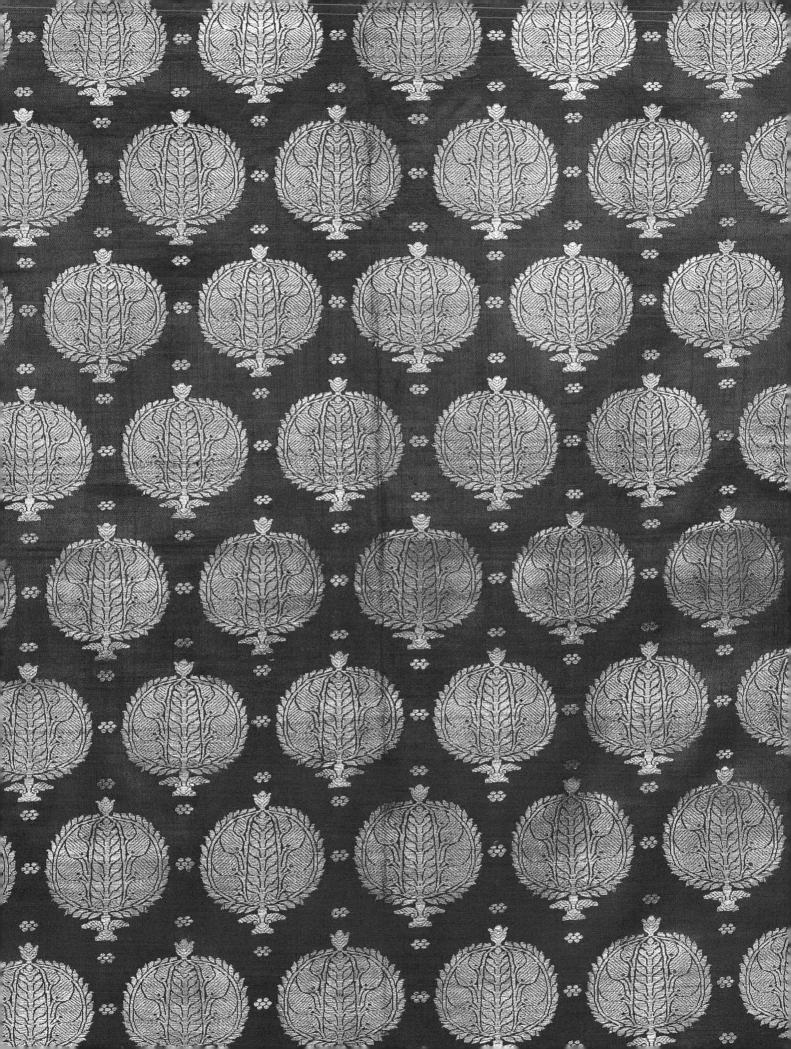

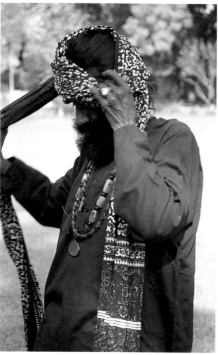

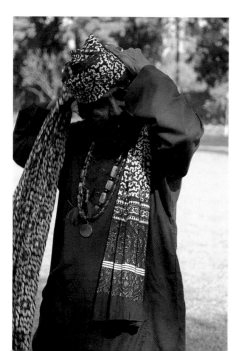

60–62 LEFT
Tying a Sindhi *ajrak* turban, Bhit Shah, Sindh, 1999

63 RIGHT
Man's turban cloth, detail
Assam
Early 20th century
Woven wool
L: 648 cm W: 33 cm
Glasgow Museums, Eth/NN/55

64 FACING PAGE
Madras handkerchief (*rumal*), detail
Possibly Chirala, Andhra Pradesh
Mid 20th century
Weft *ikat* dyed cotton
L: 536 cm W: 88 cm
These handkerchiefs were woven together and exported to Port Harcourt, Nigeria, for the Kalabari tribe. Each has had sections of threads removed in order to make an additional pattern (*i.e.* apart from the original checks). The finished *rumal* is referred to as a *pelete bite* ('cut thread').

65 RIGHT

Man wearing a waistcloth (*dhoti*), outside Bombay (Mumbai), 1997. The *dhoti* has been tied at the waist with one end pulled through the legs and tucked in at the back.

66 BELOW

Fishermen in waistcloths outside Jhelum, Punjab, 1996

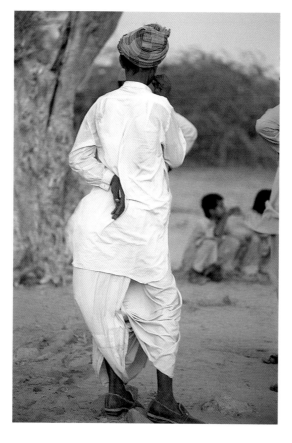

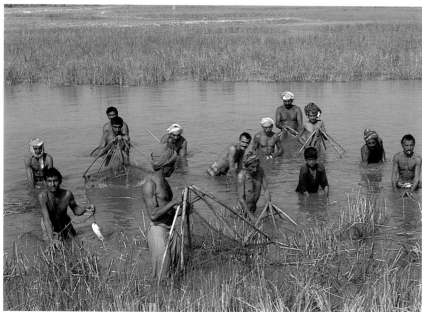

Throughout India, men wear waist- or loincloths known as *dhotis*. A *dhoti* may be draped in a number of ways but a popular style involves the fabric being wrapped around the midriff with one end pulled through the legs and tucked in at the back, to resemble loose trousers (fig. 65). Another male waistcloth, the *lungi,* commonly worn in Bangladesh, parts of India and Pakistan, differs somewhat from the *dhoti* as it is simply wound around the waist in the form of a long skirt and then fastened or tied at the waist in a knot (fig. 66).

Silk and cotton waistcloths, *lungi* or *lachas,* are common in central Punjab in Pakistan. In Chakwal, Bhera, Bhalwa, Sargodha, Jhang and Kamalia, festive *lachas* are woven in flamboyant colour combinations of yellow, pink, turquoise, dark blue, green and purple.

In Khushab, extended family workshops are responsible for the entire process of production, from spinning and dyeing the yarn to the finishing of the cloth. Staple (synthetic) yarn on power looms has increasingly replaced the traditional pit loom (figs. 67–70). *Lachas* for men usually have plain, broad, contrasting borders along their edges with similarly coloured supplementary weft borders at their ends. *Lachas* for everyday wear may have sophisticated two-colour combinations in white, maroon, blue, brown or black. The body or field of the *lacha* is commonly striped or plaid and fastened at the waist in a knot known as a *duba.* Women's *lachas* tend to have narrower borders resembling the colour of the field and are worn with contrasting headshawls or *salari* (see Shawls and Head Coverings above). Near Campbellpur and in the Potohar Plateau waistcloths are seen in compelling colour palettes with dark blue or black fields and bright pink or red borders (figs. 71, 72).

On the north-eastern frontier of India many of the tribal men favour waistcloths and women

67
Man's waistcloth (*lacha*), detail
Hamoka village, Khushab,
Punjab
20th century
Silk with gold-wrapped thread
L: 524 cm W: 82 cm
Private collection
This *lacha* was woven by Ustad
Haji Fateh Mohammed, from
whom it was purchased by the
owner. The design seen here,
known as the *ambuta* and
chhoti khoti (paisley and small
square), is popularly
commissioned for weddings.

68 RIGHT
Ustad Mohammed Hayat
weaving a shawl (salara) on a
pitloom, near Sargodha, Punjab,
1998

69 BELOW
Yarn stocked for weaving
waistcloths, Hafiz Masoodan's
workshop, Mohalla Tajpura,
Khushab, 1999

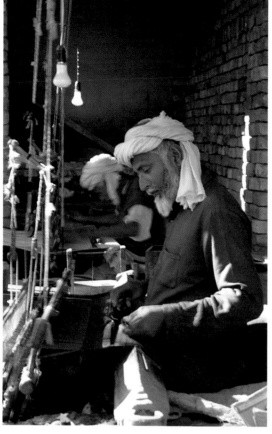

wear *sarong*-like skirts with a *chadar* or shawl. In
Assam, ceremonial waistcloths are made from dyed
and undyed lengths woven with wild silk, *eri, tussar,*
or *muga*. These may have beautiful supplementary
weft borders incorporated just above their fringed
ends (fig. 74). Woollen waistcloths using dyed and
undyed wool are also popular. In Tripura, *lungis* or
waistcloths are woven and worn by women using
striped patterns with a variety of borders and
stripes in striking colour combinations (fig. 73). In
the Manipur valley, a wraparound skirt (*phaneyk*)
often has a field of woven stripes with embroidered
borders at one or both edges (fig. 75).

The gathered skirts or *gaghra* of Gujarat and
Rajasthan are noted for their varied block-printed
and tie-dyed patterns. In Tharparkar, the *gaghra* is
also referred to as a *parha* (figs. 76, 77). Here,
farming and Meghwar groups adorn their *parhas*
with stunning embroidery using stylized floral
motifs and mirrors in a repertoire of traditional
satin, chain, button-hole, stem and couched
stitches (fig. 80).

70 FACING PAGE
Top:
Woman's waistcloth (*lacha*), detail. Jhang, Punjab. 20th century
Cotton with silk ends and borders. L: 274 cm W: 122 cm
Private collection
Middle:
Woman's headshawl (*salari*), detail. Kamalia, Punjab. 20th century
Cotton with silk borders. L: 204 cm W: 111 cm
Collection Nasreen Askari
Bottom:
Man's waistcloth (*lacha*), detail. Hasan Abdal, Punjab. 20th
century
Woven cotton and silk. L: 244 cm W: 132 cm
Private collection

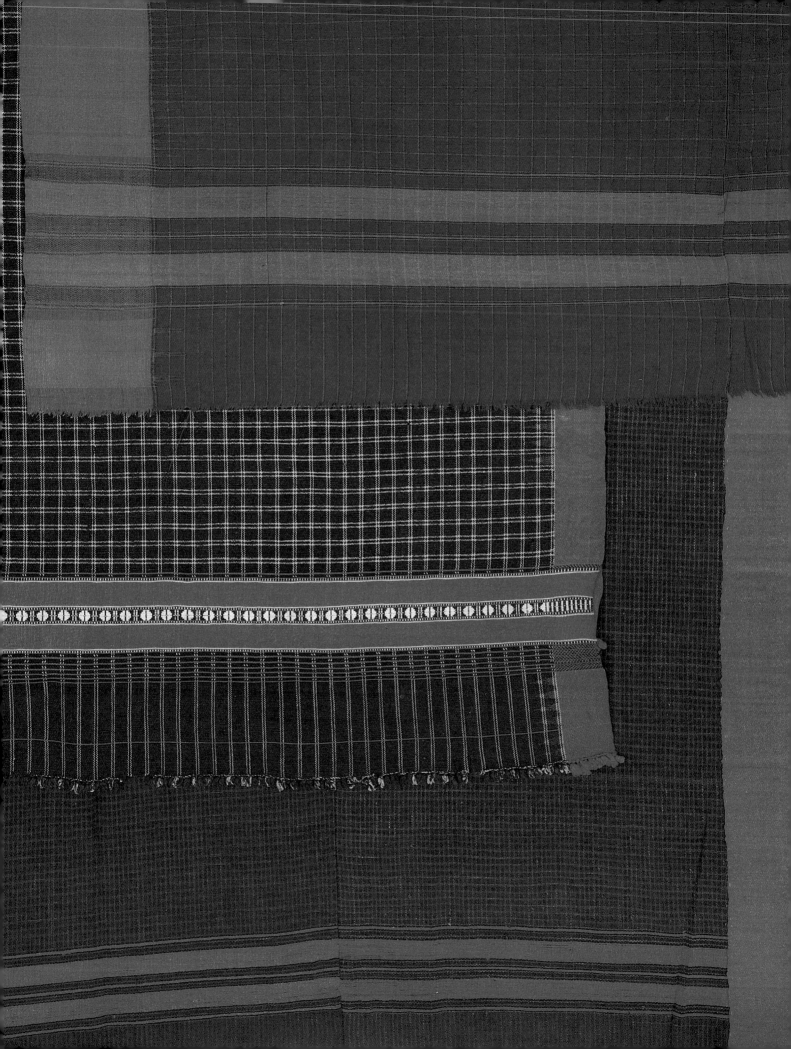

71 RIGHT
Man wearing a waistcloth
(*lungi*), Porbandar bazaar,
Saurashtra, Gujarat, 1982

72 BELOW
Man's waistcloth (*lacha*), detail
Mianwali, Punjab
Mid 20th century
Woven silk and cotton
L: 258 cm W: 240 cm
Private collection

73 FACING PAGE
Woman's waistcloth (*lungi*),
detail
Tripura
Mid 20th century
Cotton with supplementary
wefts
L: 180 cm W: 103 cm
Collection Jasleen Dhamija
There is harmony of both
colour and pattern in this
beautiful waistcloth. Fine indigo-
blue and black stripes in the
field have been offset by red
and black borders and a
decorative band of supple-
mentary wefts at one end.

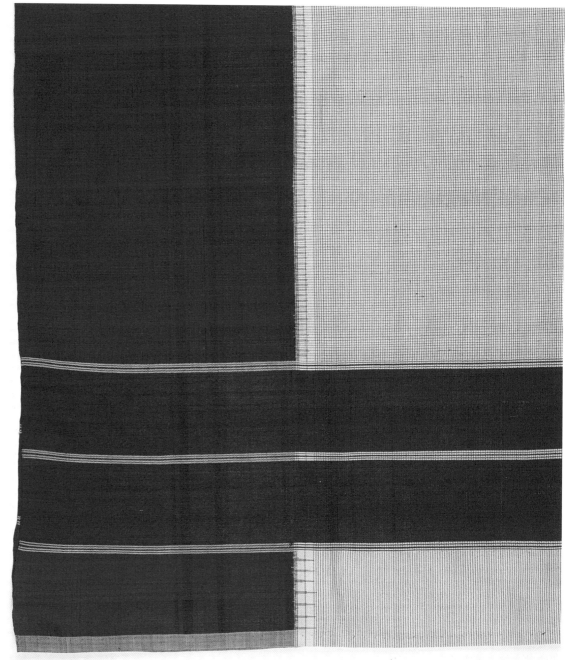

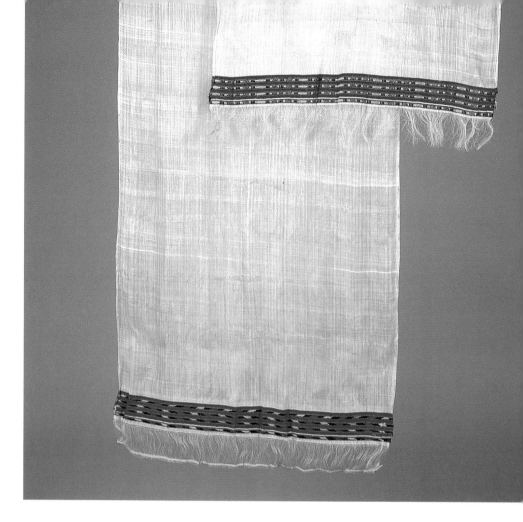

74 RIGHT
Man's waistcloth, detail
Shillong, Assam
Late 19th century
Silk with supplementary weft ends
L: 324 cm W: 50 cm
Glasgow Museums, G.M.88.109 ae

75 BELOW
Woman's waist cloth (*phaneyk*), detail
Probably Meitei group, Manipur
20th century
Cotton with supplementary warp
L: 108 cm W: 77 cm
Collection Jasleen Dhamija
The *phaneyk* warp is worn by a number of
groups in Manipur. Its border appears to be part
of the woven field but is in fact embroidered
using tightly packed stitches in colours closely
matching the field.

76 RIGHT
Women in printed skirts (*gaghras*) winnowing grain, Barmer, Rajasthan, 1995

77 FAR RIGHT
Kohli girls wearing skirts (*parhas*) and carrying fodder, Naukot, Tharparkar, Sindh, 1996

78 BELOW
Woman's skirt cloth, detail
Chittagong Hill tracts, Bangladesh
20th century
Embroidered cotton, decorated with glass beads and seeds
L: 28 cm W: 84 cm
Collection Jasleen Dhamija

79 FOLLOWING PAGES, LEFT
Man's waistcloth (*puthkalli*), detail
Toda group, Nilgiri Hills, Tamil Nadu
Mid 20th century
Woven cotton
L: 232 cm W: 148 cm
Woven by the Kotas and embroidered by Toda women, this striking waistcloth has plain woven bands and intricately embroidered patterned bands. This particular example is meant for senior Toda men who tend buffaloes, which are considered totemic animals.

80 FOLLOWING PAGES, RIGHT
Woman's skirt (*parha*), detail
Meghwar group, Bhalwa, Tharparkar, Sindh
Early 20th century
Cotton embroidered with silk, applied mirrors
L: 79 cm W: 520 cm
Private collection
Peacocks and flowers form a delightful pattern on this cotton skirt. Worked in the *pakkoh* style of embroidery, these motifs are found all over the culturally contiguous areas of Sindh, Kutch, Gujarat and Rajasthan. *Pakkoh* (literally 'solid') derives its name from the density of the stiches used: satin, button-hole, chain, herringbone and cretan.

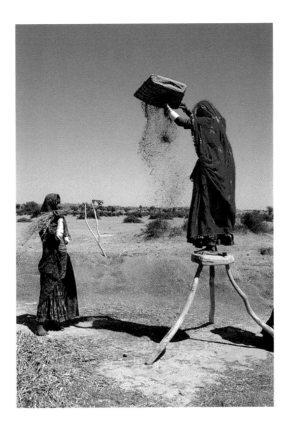

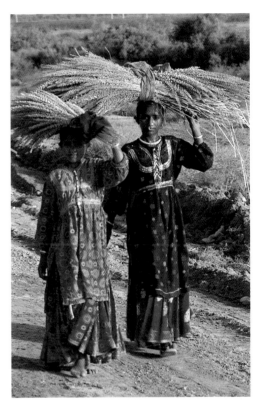

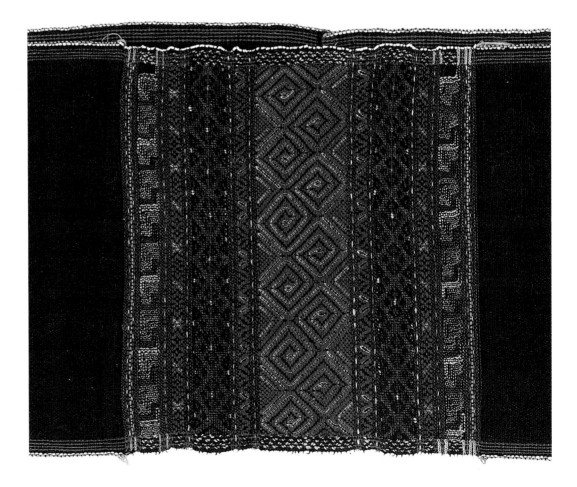

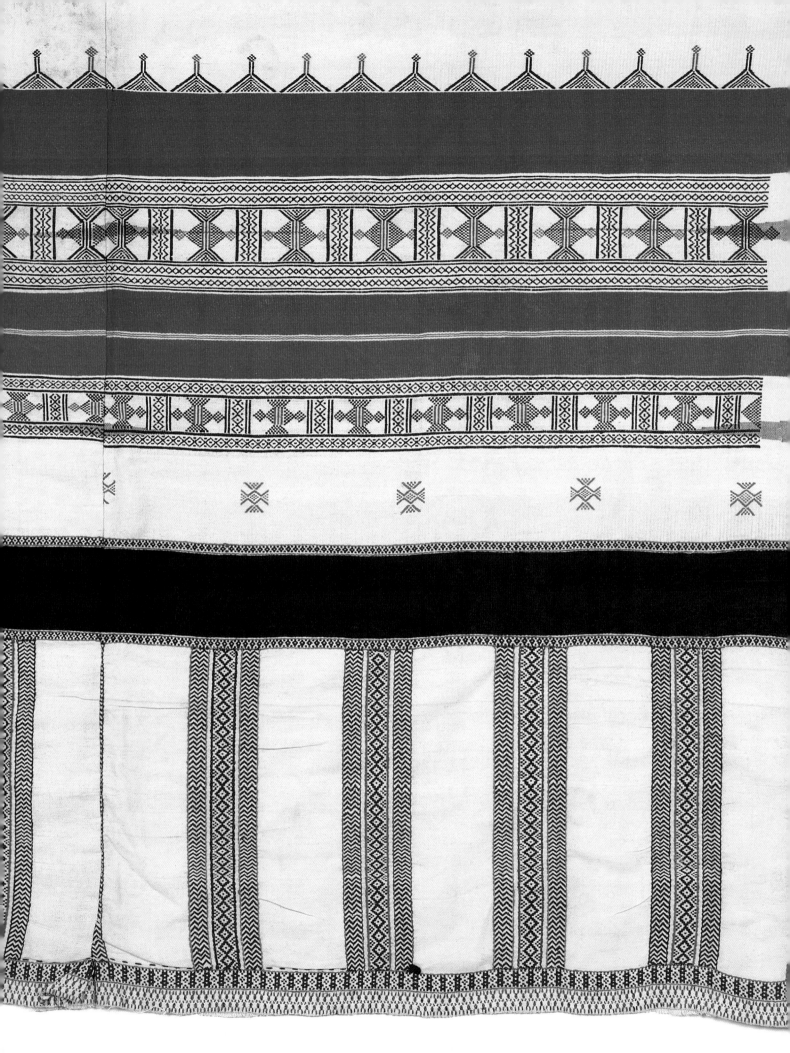

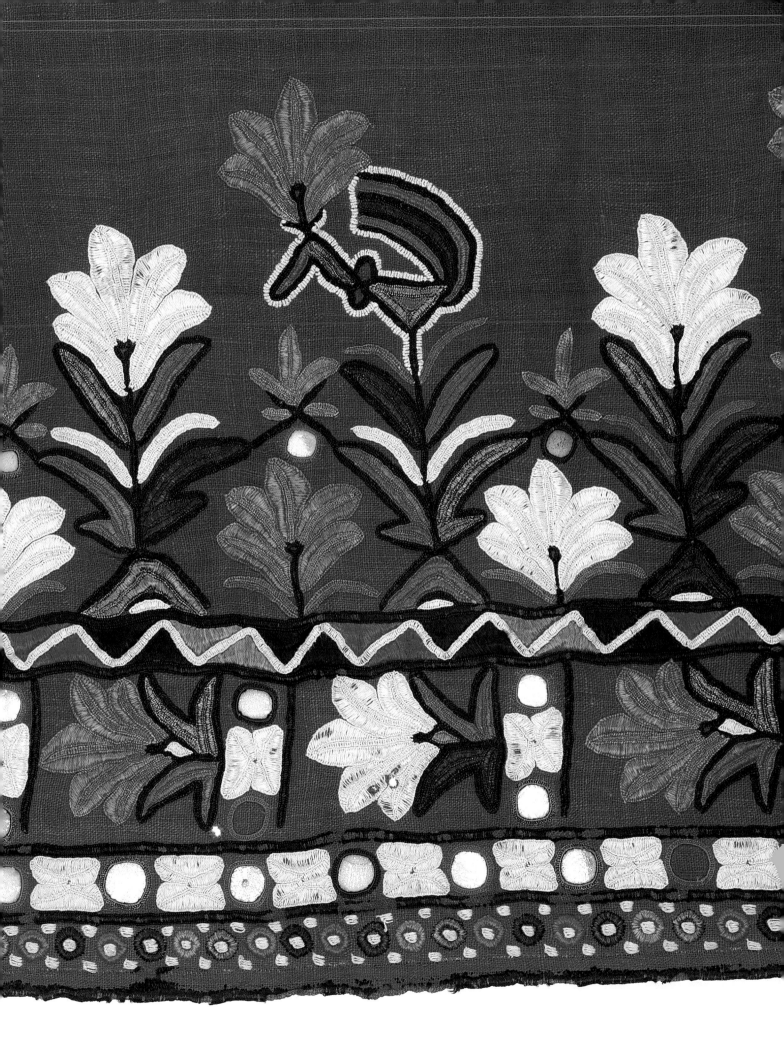

SPREADS, COVERLETS AND CANOPIES

Unsewn cloth also serves as a spread, coverlet, canopy or wrap. Ceremonial wraps and dowry cloths (*thalposh*; figs. 81, 82) vary in size and adornment, as they are primarily used for the presentation of gifts all over the region. Mahar groups in the desert regions of both India and Pakistan embroider their coverlets and dowry wraps with finely executed floral and geometric patterns. Bridal gifts consisting of the Quran, jewellery and cosmetics are presented in envelope-shaped bags (*gothro*; fig. 83) made by folding or pleating pieces of embellished cloth (*bhujki* or *bushkiri*; fig. 84). Lengths of unsewn cloth on which communal meals are served and eaten (*dastarkhwan*), tablecloths (*maizposh*) and coverlets for beds (*khes*) are also popular wedding gifts (figs. 85–87, 89).

The term *khes* has traditionally been used to describe any thick cotton cloth used as a spread. In his catalogue *Indian Art at Delhi, 1903*, George Watt noted a large assortment of *khes* from all parts of the Punjab: Derajat, Dera Ismail Khan, Jhang, Multan, Shahpur, Kohat, Peshawar, Muzaffargarh, Lahore, Karnal, Ludhiana and Patiala, although many of these centres no longer produce *khes*. The term is currently used to describe a dense twill or double-woven cotton or cotton-and-silk cloth used for bedinen. *Khes* may be plain, striped, plaid or contain a repeating geometric pattern with the occasional use of gold- and silver-wrapped threads.

Khes from the Punjab are found in two-colour combinations with plaid fields, known as *chandni khes* and *gumti khes*. Combinations popular in Sindh are red, green, yellow, black and blue in patterns known as the *pabaro* (lotus), *billi*

butho (cat's face), *punj gullo* (five flower), *tike gul* (round flower) and *bulbul chasm* (nightingale eyes). The best-known silk *khes* from Punjab is the *shia-khani* with a chevron pattern in dark blue and white (fig. 88).

Canopies (*shamianas*) and wall panels (*qanats*) are lengths of cloth used to create or adorn spaces (fig. 92). Traditionally, printed cotton lengths pegged into the ground were used to delineate work and sleeping areas for participants at hunts, festivals and for public worship. More ornamental versions using rich silk or velvets with gold embroidery were used at the imperial courts. Today, *qanats* are popularly used at weddings, festivals and public gatherings (fig. 90).

Sadly, costumes which had functioned as symbols of identity for the different peoples of South Asia have now lost some of their intrinsic significance. Traditional rituals are giving way to new customs and new modes of social interaction. Western fashion and the desire for innovative changes in dress are beginning to override the importance of traditional forms of identity, with the result that a more uniform emphasis on dress is emerging. In northern India and Pakistan in particular, regional variations in costumes have almost all been eliminated by the adoption of *shalwar kameez* (gathered trousers and tunics) worn by both men and women. Traditional materials and techniques have also been overtaken by man-made fibres and by mechanization. Cost-effective mass production is better able to fulfil growing demands for clothing and textiles; and while mechanized production has magnified the volume of cloth being produced, the ritual importance once invested in a length of hand-made cloth is gradually being lost.

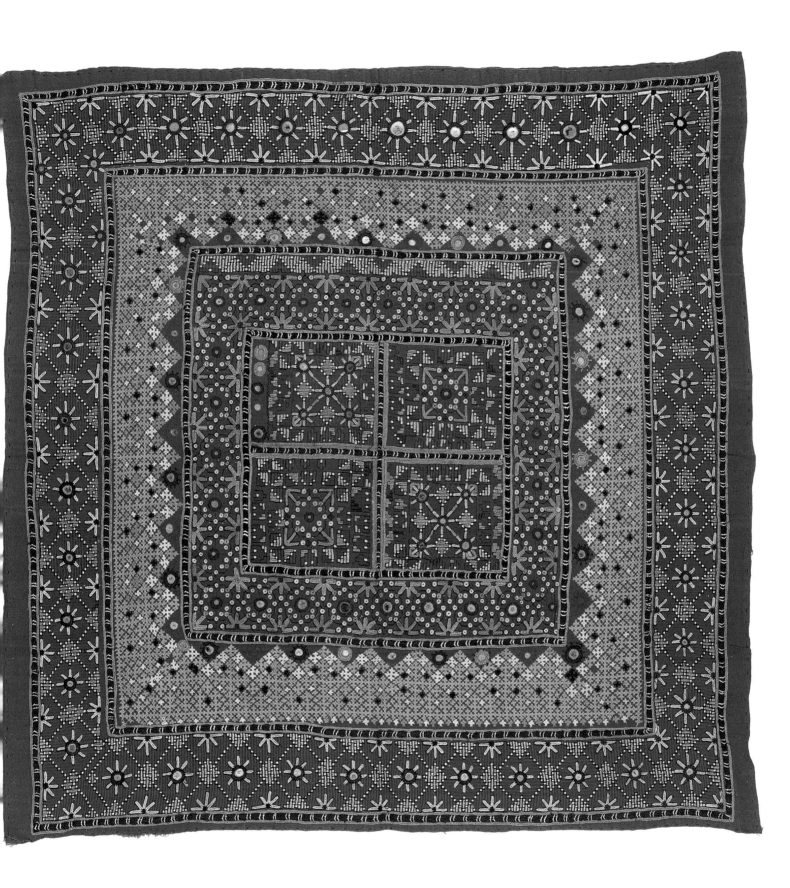

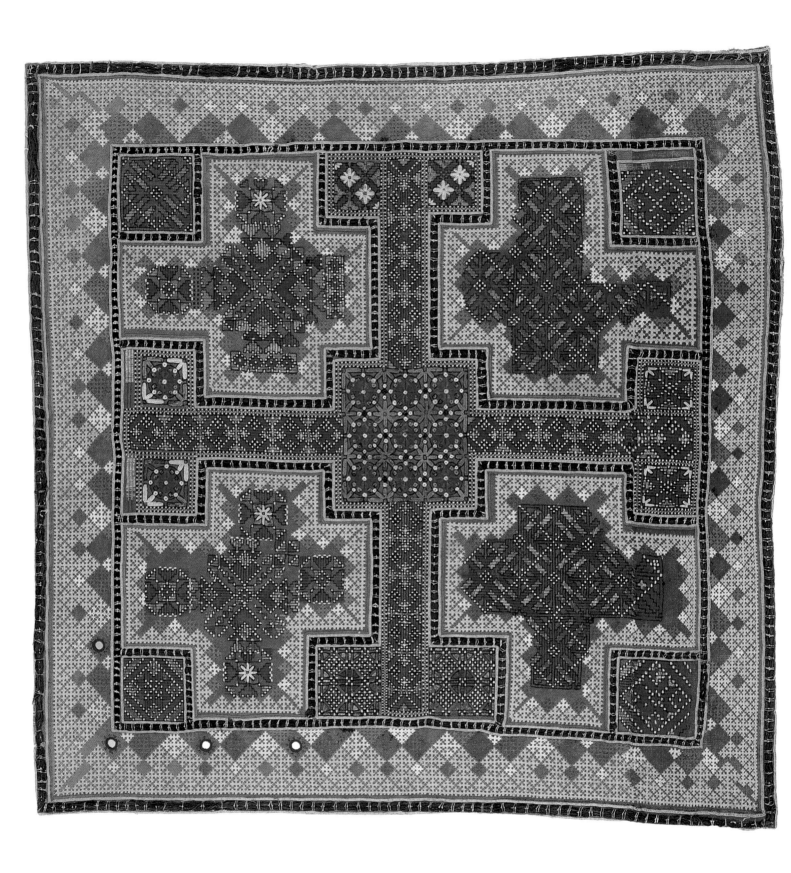

82 FACING PAGE
Dowry cloth or cover
(*thalposh*)
Mahar group, Vijnot, Sindh
Early 20th century
Cotton embroidered with silk
and decorated with silver-
wrapped thread and mirrors
L: 63 cm W: 63 cm
Collection Nasreen Askari

83 RIGHT
Quilted dowry bag (*gothro*)
Saami group, Mullakatyar, Tando
Mohammed Khan, Sindh
Mid 20th century
Cotton with silk embroidery,
quilted, applied mirrors and
tassels
L: 71 cm W: 54 cm
Collection Nasreen Askari

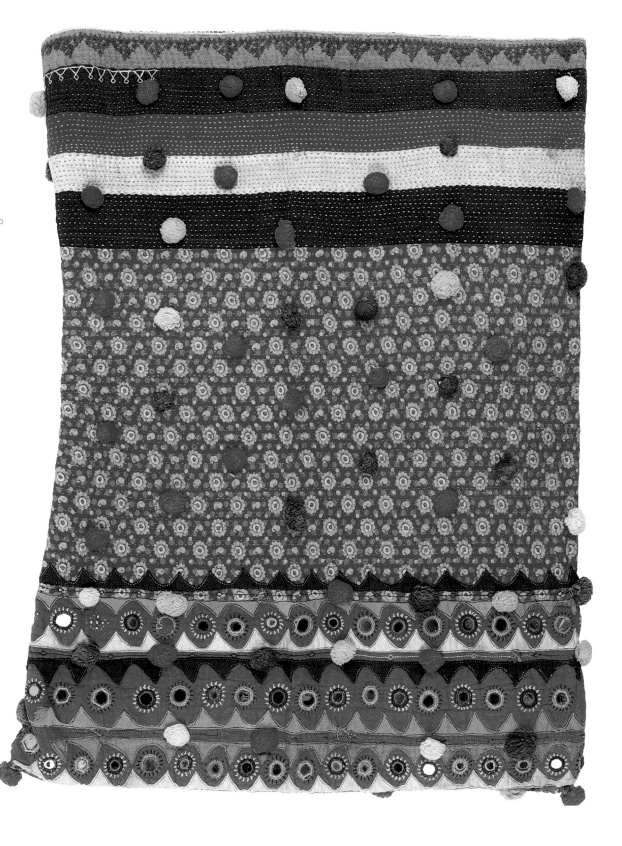

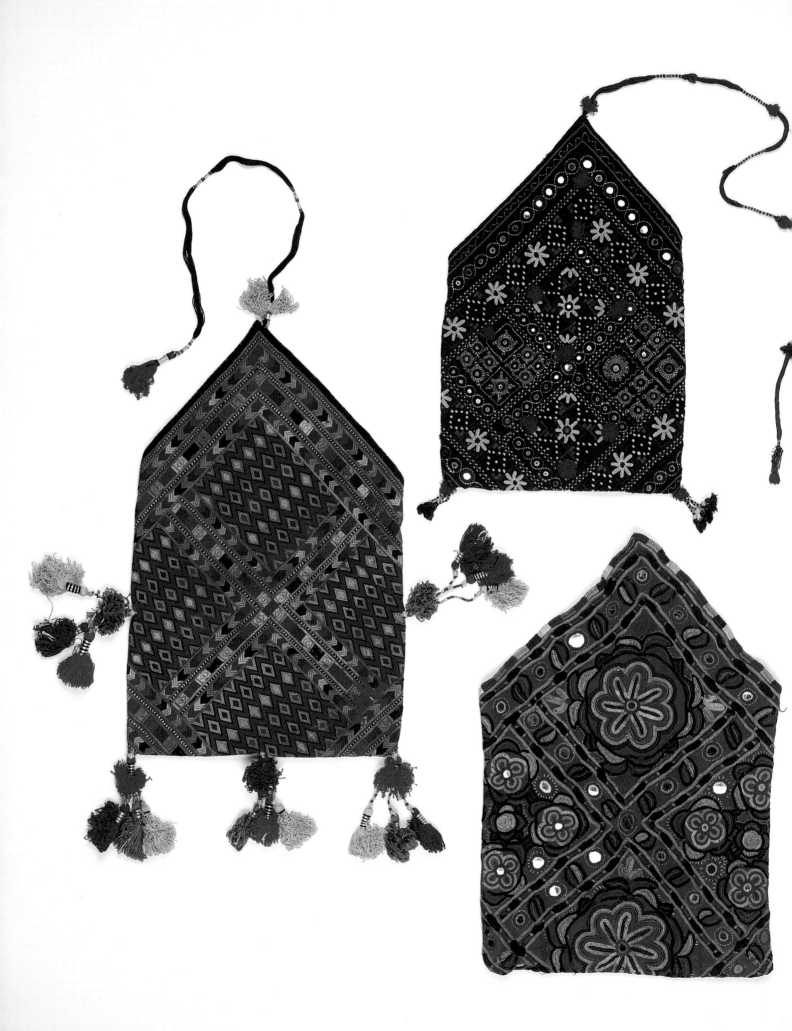

84 FACING PAGE
Dowry bags (*bhujki* or *bushkiri*)
Left:
Marri group, Sulaiman range, Baluchistan
Mid 20th century
Cotton embroidery with floss silk
L: 45.5 cm W: 31 cm
Top right:
Mahar group, Ghotki, Sindh
Mid 20th century
Cotton embroidered with silk, applied mirrors
L: 37.5 cm W: 25.5 cm
Bottom right:
Tando Ghulam Ali, Sindh
Mid 20th century
Cotton embroidered with silk, applied mirrors
L: 43 cm W: 35 cm
Collection Nasreen Askari

85 RIGHT
Man wearing a printed cotton scarf
(*rumal*) around his shoulders,
Mirpurkhas, Sindh, 1996

86 BELOW
Ceremonial cloth
Nagaland
Late 19th century
Printed cotton
L: 92 cm W: 92 cm
Glasgow Museums, 98.183d

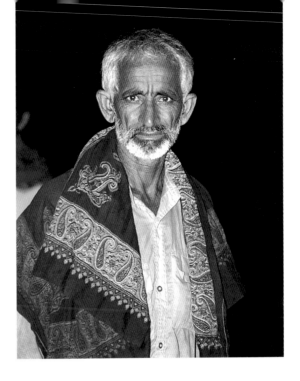

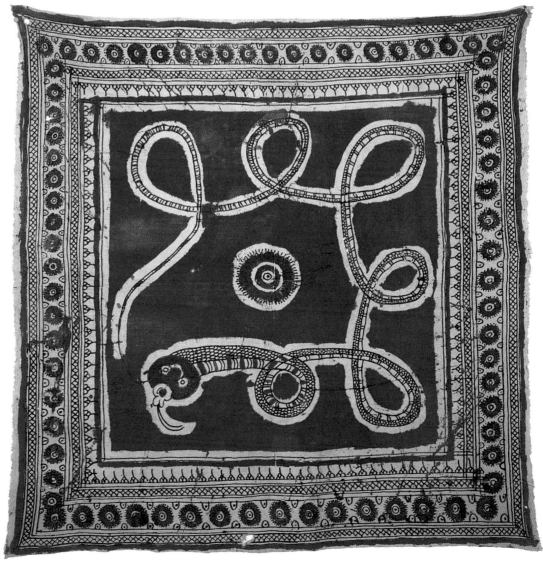

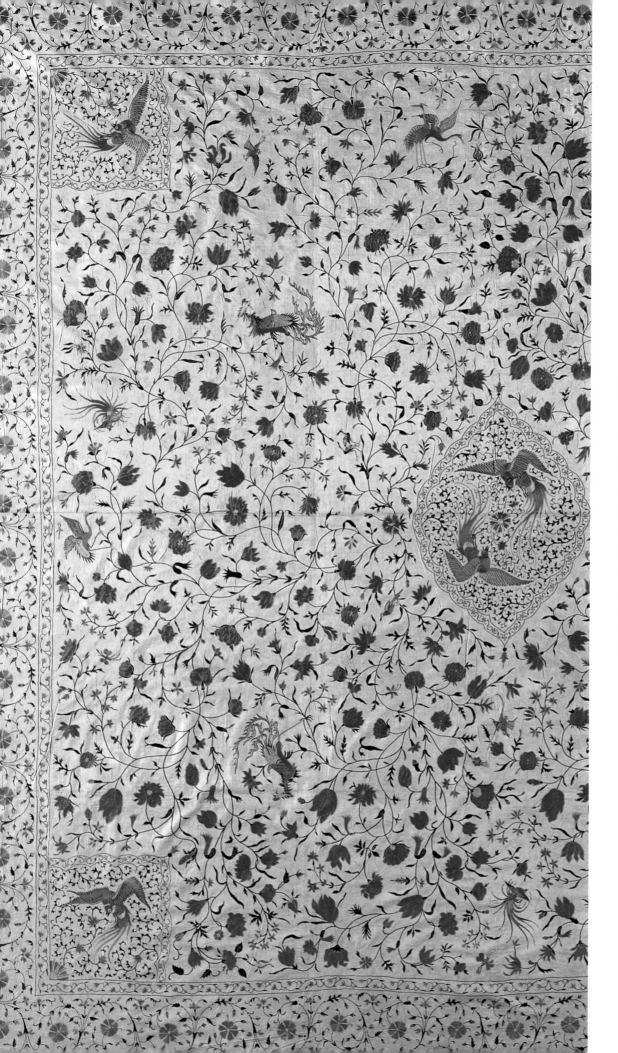

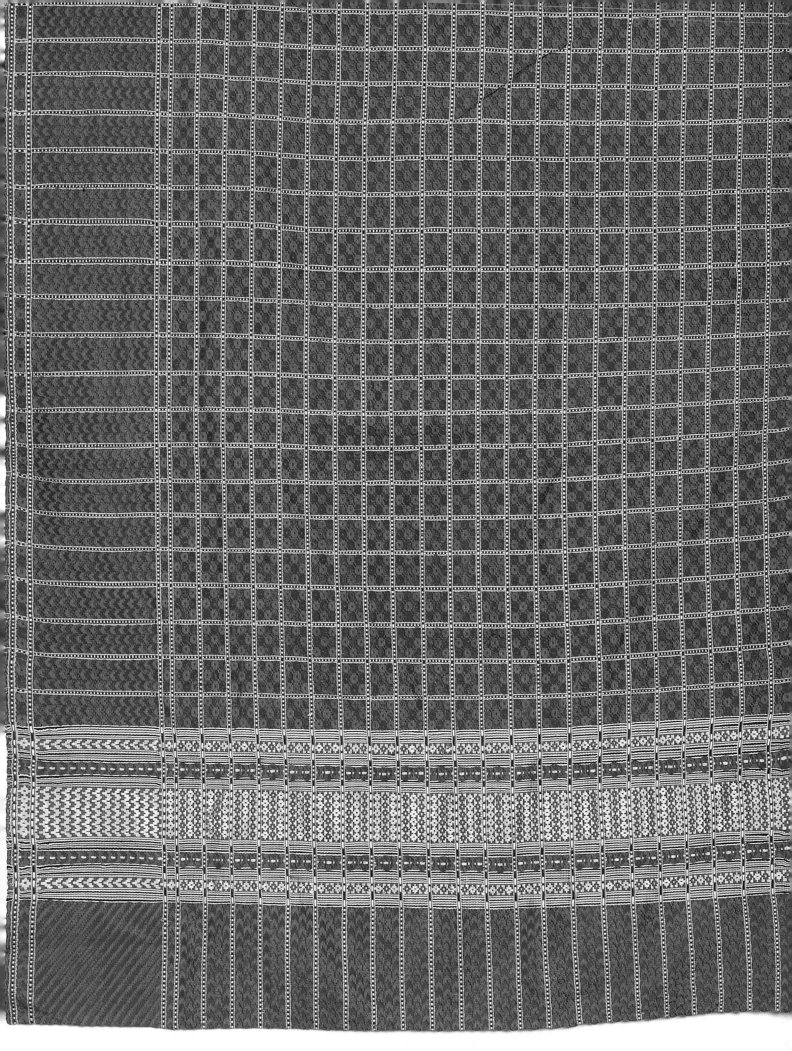

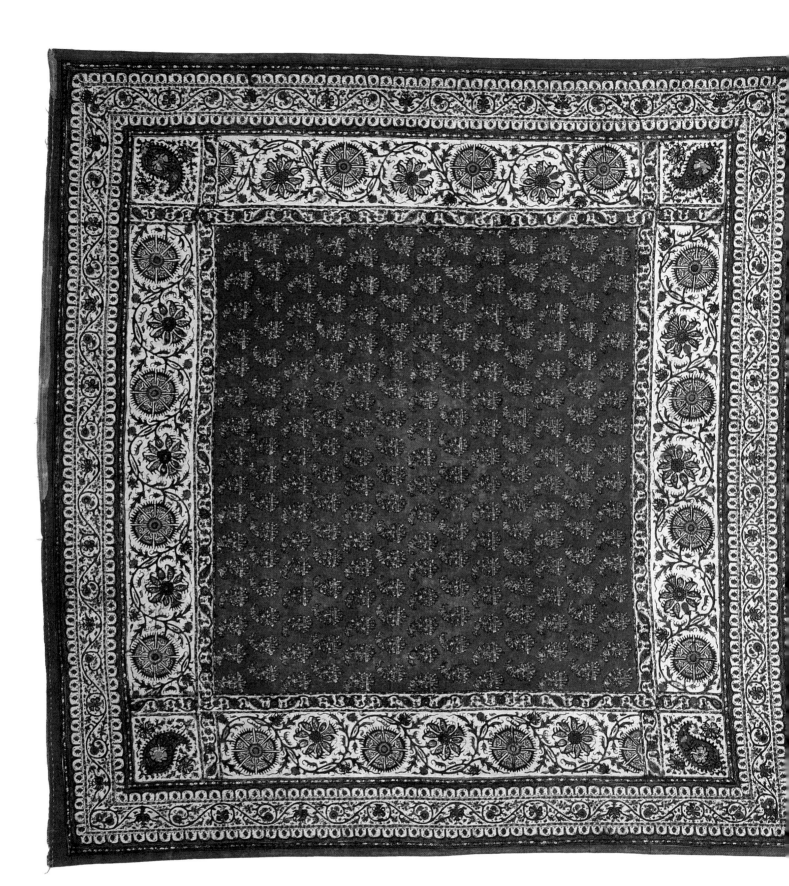

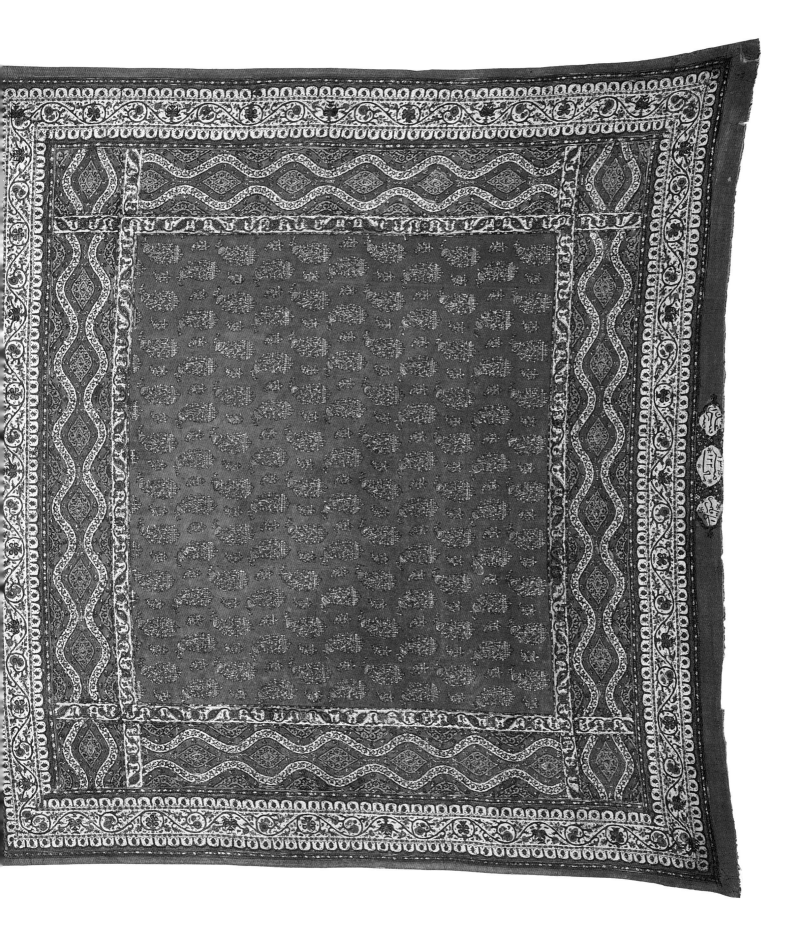

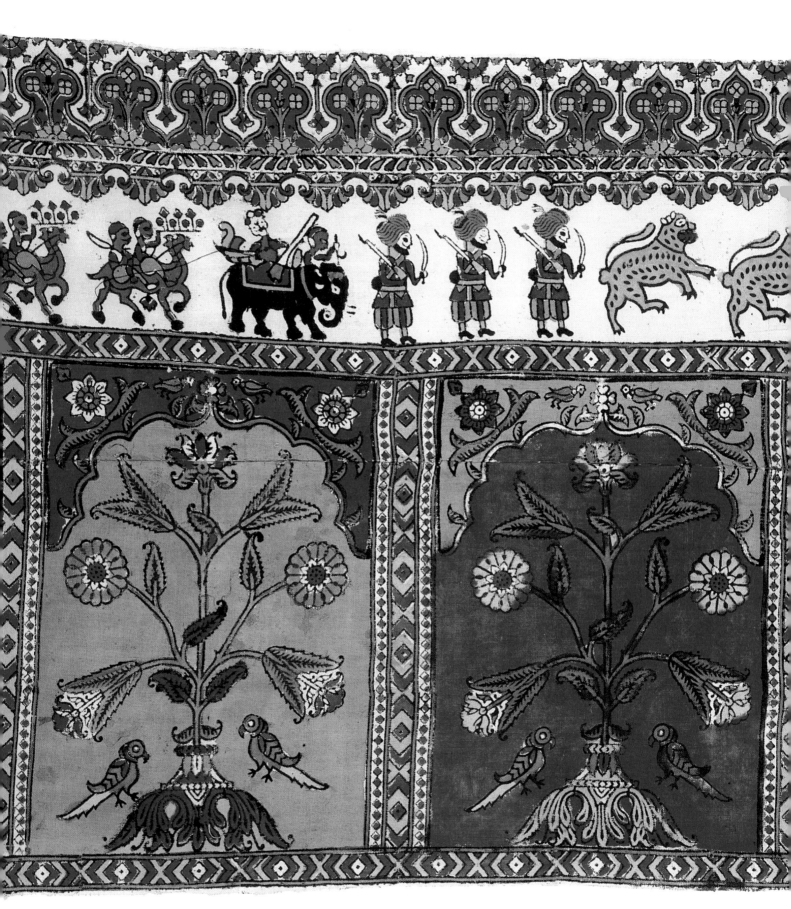

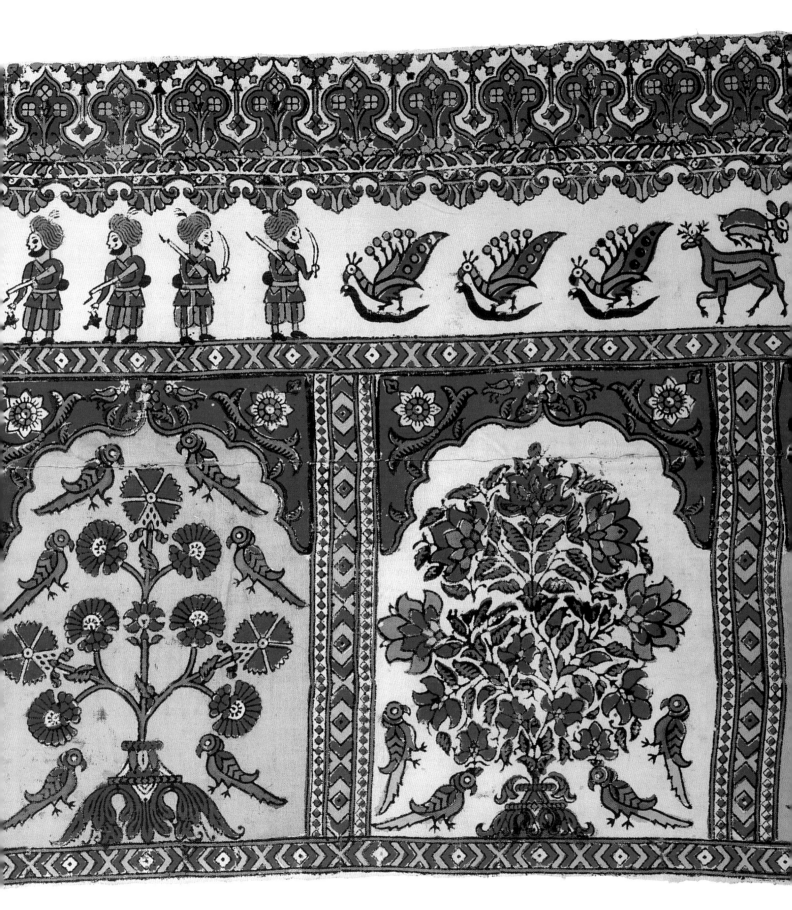

90

Portable screen (*qanat*). Probably Punjab. Late 19th century. Block-printed cotton. L: 785 cm W: 91cm. Glasgow Museums, E6735

In the late nineteenth century Mughal patterns continued to be popular for commercially produced urban textiles. Lengths of printed cotton were used as moveable partitions to create spaces for public events and ceremonial occasions. The pattern on this screen shows architectural elements in the form of cusped arches decorated with flowers, trees and birds. One border shows whimsical figures possibly on a tiger hunt.

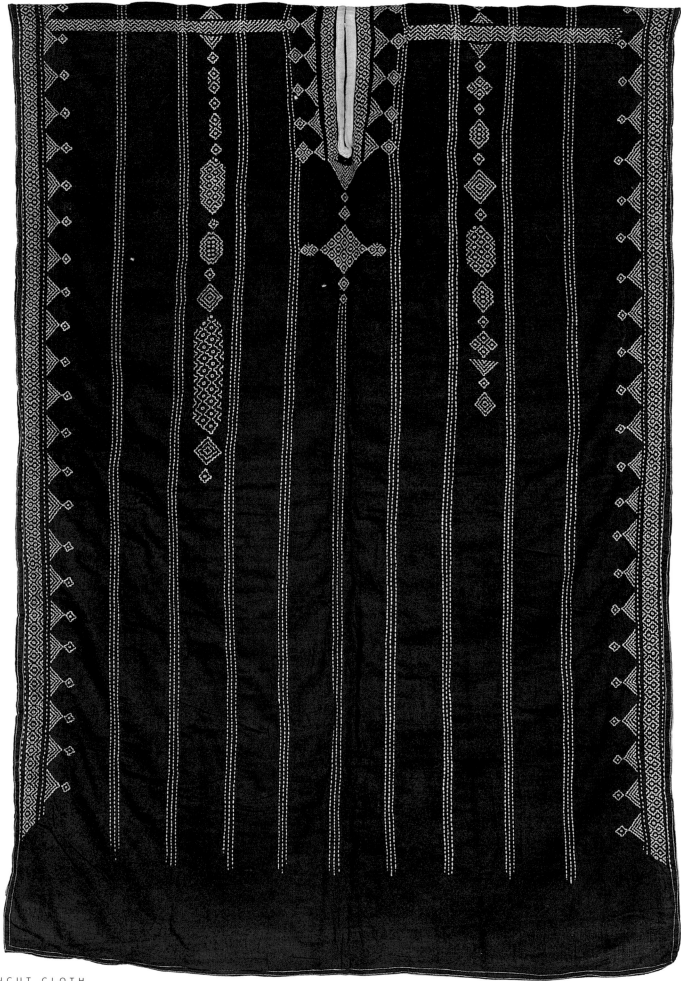

91 FACING PAGE
Man's jerkin (*alfi*)
Bhit Shah, Sindh
Late 19th century
Cotton with cotton embroidery
L: 109 cm W: 80 cm
Collection Nasreen Askari
Worn by the singing disciples (*ragai faqirs*) of the
Sufi poet and philosopher Shah Abdul Latif
(1689–1752), this indigo-dyed jerkin, made from
a single length of cloth folded over, has been
embroidered in a *kanbiri* stitch, formerly reserved
for Syeds, descendants of the Prophet
Mohammad.

92 RIGHT
Detail of velvet wall-hanging decorated with
gold-thread (*zardozi*) work, *ca.* 1950
Collection Mir Ali Murad Khan Talpur, Faiz Mahal,
Khairpur, Sindh

93 BELOW
Woman's dress, detail
Assam
Wool with embroidered silk edging around the
neck and chest
L: 117 cm W: 122 cm.
Purchased at the *Colonial and Indian Exhibition*,
London, 1886. Glasgow Museums, 86. 67 cb
This dress demonstrates the use of uncut cloth
as a garment.

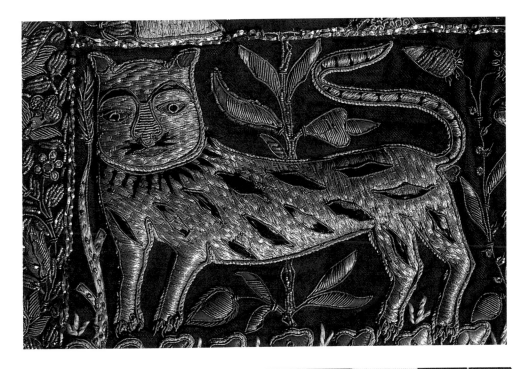

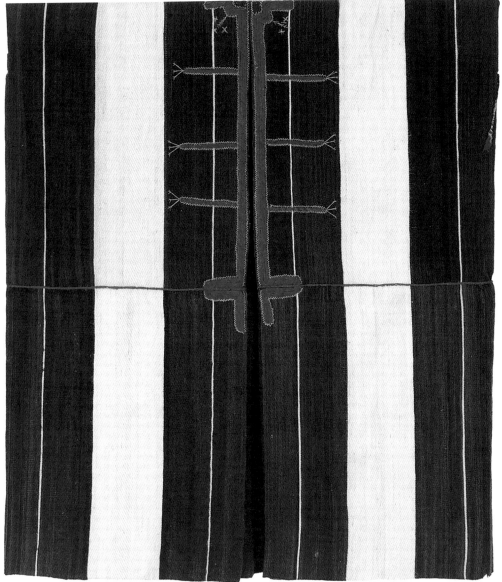

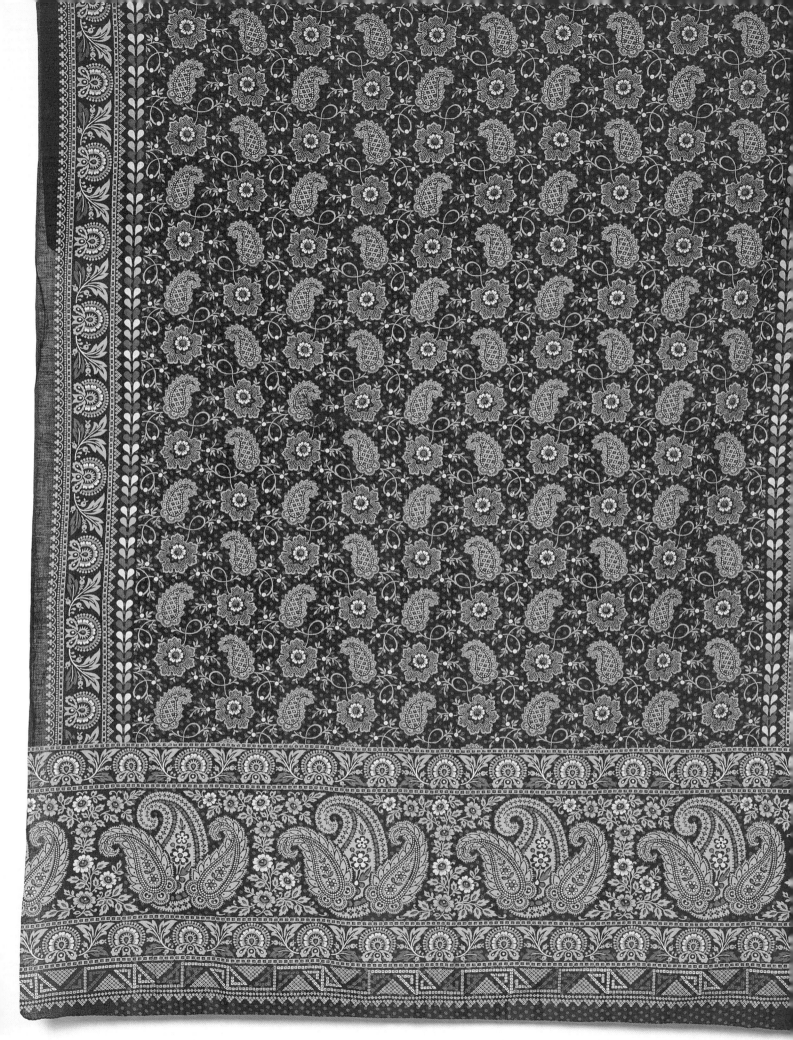

at the end of which Edinburgh would cease production and Norwich was eclipsed to such an extent that it was Paisley's name that was attached to the product.

In the early nineteenth century Paisley was also threatened by French rivals. Britain had been ahead of France in establishing the fashion for the Indian shawls, but, once the French armies returning from expeditions in North Africa and the Near East introduced shawls to their ladies, they were taken up with great enthusiasm. The new, lightweight, classically inspired fashions adopted by the post-Revolutionary élite required an accessory that was both warm and capable of elegant draping. The shawl was both, and Napoleon's Empress Josephine is known to have been a particular devotee. Indeed, the number of expensive Kashmir shawls in her possession (some two hundred if accounts are to be believed) may have been one factor in Napoleon's subsequent encouragement of the establishment of shawl manufacturing in France.

Unlike the British producers, who continued to use the drawloom, manufacturers in France were at first willing to experiment with reproducing the laborious Kashmiri twill-tapestry technique, using women and children in order to keep labour costs down. Whilst producing shawls of high quality, the process could not compete on price, and soon the majority of French shawls were also being drawloom-woven. In 1818 the invention of the Jacquard loom, in which the pattern production is controlled by a loop of punched cards, once again gave the French industry the advantage. The system was flexible enough to produce the most complex of patterns, thus freeing the shawls from the repetitiveness of drawloom-woven designs, and at the same time it smoothed the very toothy, jagged edges typical of drawloom patterns, to produce something much closer in spirit to the original Kashmir products.

Before a pattern can be set on to the loom, a design has to be produced which can be translated either into the tied harness of the drawloom or into the punched cards of the Jacquard. During the century-long period of shawl production in Europe, this was done in a variety of ways, but almost always through a synthesis of Indian inspiration and European taste. In the latter years of the eighteenth century, what every European woman of fashion and taste desired was a Kashmir shawl. If, however, she could not afford such a prize, her next choice would be a European-made shawl which looked, and if possible felt, as much like an imported Kashmir as was achievable. The feel was always a problem, which, over the years, the manufacturers sought to resolve by experimentation with various combinations of yarns. Silk was often used as a warp, both for its softness and also because it was stronger than any finely spun wools of the early nineteenth century. Sometimes, to soften the feel even more, a yarn with a silken core but an outer covering of wool would be specially spun for the shawls. Subsequently, as textile technology improved during the century, wools were spun that were suitable for use in shawl weaving. Fine Australian merino imported into, and spun in, West Yorkshire was often the preferred choice of the manufacturers. Reproducing the Indian designs was perhaps easier. All the manufacturer had to do was buy up examples of the latest imported shawls and have the designs reinterpreted.

Shawls of the first quarter of the nineteenth century generally follow a fairly standard format. They are rectangular (average size 240 × 120 cm) with a plain or filled central area, and a border of large paisley motifs (fig. 106). On the Kashmir shawls, the motifs tend to march in procession from one side of the shawl to the other. European shawls, however, tend to have motifs which either occur in facing pairs or which reverse direction halfway across the border. This was a reflection of

106 FACING PAGE
Detail of a shawl from the very
early years of the nineteenth
century, when manufacturing
was just beginning in Paisley.
The motif in the border is large
and obvious.
Paisley Museum and Art
Galleries

the technicalities of the weaving processes used.
The other standard format of these years is the
square (generally 175 × 175 cm). In Kashmir, square
shawls were usually made for export to the Turkish
or Persian markets, and tended to have a different
patterning from those made for the Indian market.
Within an outer border they often had a large
circular medallion, echoed in the corners by
quarters of the same designs, and these were
differentiated from the field (or background) by the
use of different patterns. In Kashmir, these were
called moon shawls. In Paisley, where perhaps the
moon is more often obscured, they were given the
more prosaic nickname of pot-lid shawls.

As time passed, the motif on the Kashmir
shawls, which had originally been recognizable
bunches or vases of identifiable flowers such as
irises and carnations, became less and less
naturalistic, until the paisley shape became a mere
conventional form. The borders increased in size
and patterning of the field became more and more
common. European copies tended to follow these
formats, and a large measure of the appeal of these
shawls may well have been the romantic
association with the 'mysterious' East. But for every
action there is an equal and opposite reaction. In
the second decade of the nineteenth century,
French taste had a small rebellion against the Indian
designs, and M. Ternaux, the same gentleman who
had experimented with twill-tapestry weaving,
declared an intent to produce shawls that had a
more distinctively French look to them. Twelve
shawls destined for Napoleon's court were
designed by the painter Isabey with "garlands
copied from Europe's most exquisite flowers".[3]
These were welcomed by one commentator as a
change from "the bizarre and muddled
ornamentation of foreign shawls".[4] This seems to
have been a minority view, however, and the
European shawl industry generally seems to have
continued its wholesale copying of Kashmiri shawls.

As the manufacture of shawls in Europe
continued, their design almost developed into an
industry of its own. Individual designers sometimes
established their own studios where they
developed their ideas, passed them on to skilled
draughtsmen to turn into working drawings, and
then sold them on to manufacturers in whichever
weaving centre wished to buy them. Since French
taste tended to dominate European fashion, most
of the design studios were situated in Paris (fig.
107). The largest manufacturers, in all the major
weaving centres, maintained their own design
studios. But still the majority of the shawls
appeared with designs based on the paisley motif
until about 1830, when the beginnings of a change
occurred. The change happened both in Kashmir
and in France. In Kashmir it was manifested in the
introduction of animals and human figures into
some of the shawls. In Europe it went much
further, and appears to have begun with a French
attempt to seduce customers away from Kashmiri
shawls. After all, variations on the Kashmir shawl
theme had now been popular for more than thirty
years in France and fifty years in Britain. Perhaps the
manufacturers sensed a feeling of boredom? In any
event, French designers, notably Amedée Couder,
who established his own studio in 1820, began
experimenting with a style relying heavily on
architectural features such as mosques, with plants
and figures.

For the Paris Exhibition of 1834 Couder
designed a shawl which he entitled the Isfahan, after
the Persian city, and had it woven by the
manufacturer Gaussen. It excited much comment
for its Persian-style buildings, the flags of which all
pointed to a central medallion, and for its
cartouches of Arabic script. These declared:
"Entered for the Exhibition of French Manufactured
Products, 1834", as well as the names of the
designer and manufacturer. It certainly seems to
have made an impression on one Paisley

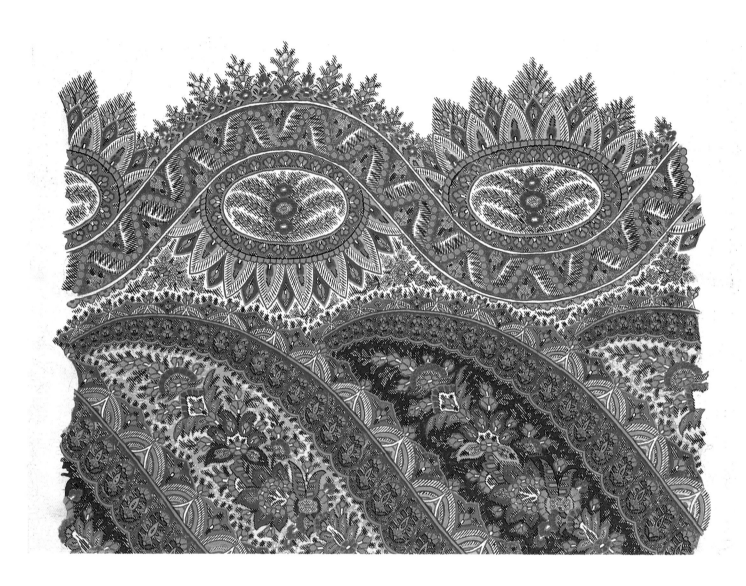

107
Design
French
ca. 1860
Paint on paper
Paisley Museum shawl archive
This design shows the stamp of
one of the Paris studios.

manufacturer–designer, who must have visited the exhibition. In recent years Paisley Museum has acquired a shawl which, on close inspection, exhibits the same general pattern layout as the Isfahan (though not the same details) and similar cartouche inscriptions. These proclaim the shawl to be of *QUAL.Y. SUPERIOR*. Further study revealed a number *159* (possibly a pattern number), the word *PAISLEY*, a date *1835* and the initials *B. & W.* and *J.W.* The Paisley Trade Directories for 1835 include a shawl-manufacturing company by the name of Baird & Wallace, one of whose partners was James Wallace ("J.W."). No further details of this interesting shawl have yet emerged, but it is possible that James Wallace visited the 1834

exhibition and liked the Couder shawl. He must have sketched the general layout of the shawl, either on the spot or from memory later. On his return to Paisley he produced his own version. This is now one of only two shawls in the Paisley Museum collection with a Paisley manufacturer's identifying mark woven in.

Gaussen, it appears, had not been technically satisfied with his rendering of Couder's Isfahan design. In 1839 he exhibited at the next International Exhibition a technically brilliant version of another Couder design, called the Nou-Rouz, depicting scenes of the celebration of the Persian New Year. This masterly piece of weaving, at least two examples of which are known,[5] was the

inspiration for another shawl in the Paisley Museum collection (fig. 108), though unfortunately its provenance is unknown. The Paisley example is square, as opposed to Gaussen's rectangle, and lacks the long architectural borders at each end. The central element, however, is the same, with the long procession of turbanned figures processing around the inner edge of the borders, some mounted on horses or camels. As with the Gaussen shawl, the most striking motif is the diagonally placed elephant and howdah in each corner. We may never know whether this was another example of a Paisley manufacturer visiting a Paris exhibition and coming home filled with inspiration. What we do know is that this attempt to wean the customers away from the traditional styles of shawls was short-lived, and soon the manufacturers returned to the infinite variations of the paisley motif. In retrospect it seems ironic that the French designers, in trying to promote designs other than those imitated from Kashmiri shawls, should choose other design elements that were so clearly based in the Orient. In any case, the shawl-buying public were soon demanding the return of the familiar motifs.

Accordingly, the European manufacturers turned once more to the inspiration provided by Kashmir. In 1837 the Frenchman Fleury Chavant's travels in India resulted in the publication of the *Album du Cachemirien*. It consisted of tracings from shawls made in Kashmir which he felt were the most likely to appeal to French taste. It gave French and other European manufacturers access to the best of Eastern design, and at the same time the best chance of tailoring their products to the various oriental markets as the export trade grew. Overland taxes in Asia often made Kashmir shawls prohibitively expensive for the Turks and Persians, and European shawls were increasingly filling the gap. Chavant went on to produce another twenty or so albums, which had an influence on design. But

the era of the pictorial shawls had left its mark. The most famous French designer of shawls, Anthony Berrus, did not produce pictorial views in the manner pioneered by Couder, but he did introduce many pictorial elements into his fantastical creations. He developed the vegetal style of paisley motif so popular during the 1850s, and included realistic flowers, jungle-like backgrounds and zoomorphic paisleys. His style influenced shawl-makers throughout Europe, since French taste was still seen as superior.

Berrus is known to have sold his designs to manufacturers in Paris, Lyons, Nîmes, Paisley and Vienna, and some of his designs were now being sent out to Kashmir. But because most of the biggest manufacturers employed their own designers, Berrus's work was probably never produced by the most technically proficient makers. Paisley-based manufacturers brought French designers into the town in order to teach the local workforce, or sent their designers to Paris for a period of several months' study. The Edinburgh manufacturer McDonald, of the firm Gibb & McDonald, is known to have visited Paris every year from 1815 until almost the end of the Edinburgh industry in order to purchase designs. Thomas Holdway, a designer who worked initially in Edinburgh and later in Paisley, won a £40 prize for shawl designs and spent the money on a study trip to Paris. The increasing number of international exhibitions, including the Great Exhibition at Crystal Palace, London, in 1851, also served to promote the cross-fertilization of ideas between manufacturers in different countries. However, what some might see as cross-fertilization others perceived as industrial espionage. In Britain in particular, there were constant accusations that one manufacturing centre had stolen and undercut the designs of another. This led to the government allowing the patenting of shawl designs, from 1842, to allow protection for a varying number of

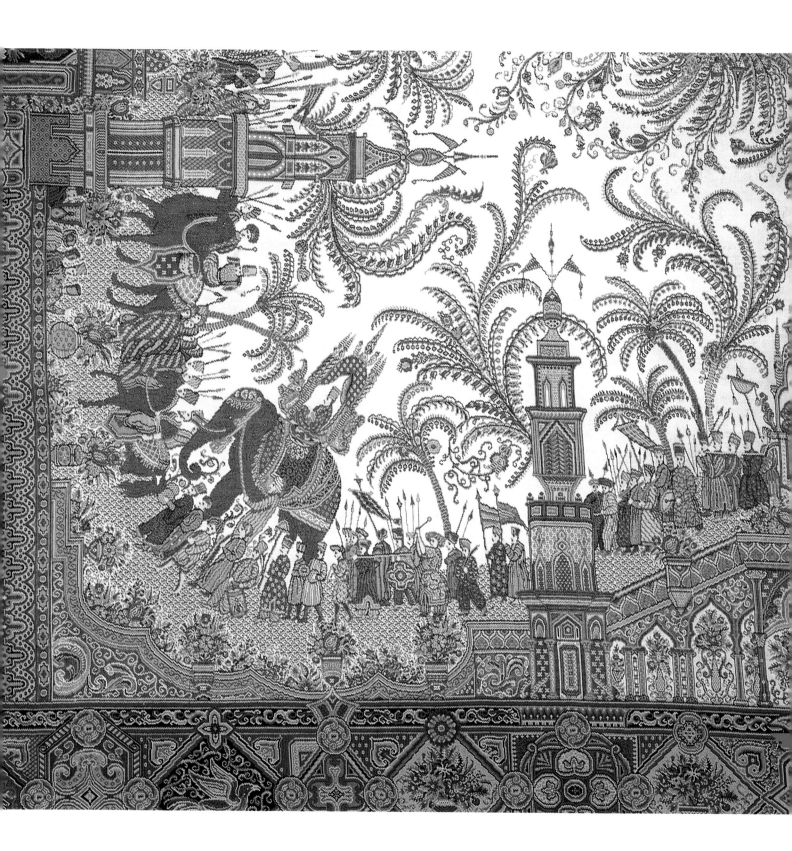

months (fig. 109). The pirating of designs, the copying from albums or from other shawls and the purchase of designs by one manufacturing centre from another all contribute to the difficulty of attributing shawls to their place of origin. This difficulty was recognized at the time, and the competition engendered by the 1851 exhibition led to calls for manufacturers to mark their products in some way. This had previously happened only very occasionally, as with the Isfahan and its Baird & Wallace derivative (fig. 110). Many French manufacturers now began weaving names or initials into their best products. Apart from Baird & Wallace, only two other Paisley manufacturers are known to have employed this device. A shawl with the name John Cunningham concealed within the design is held by the Victoria and Albert Museum, while Paisley's own collections hold a spectacular example produced by "D. Spiers & Co.", which is documented as having been woven in 1867 as an exhibition piece. Later, to save the extra expense of cutting Jacquard cards to weave the name, French manufacturers took to sewing labels to the reverse

of the shawl, recording past medal-winning successes by the company.

Perhaps one of the most astonishing twists in this whole convoluted tale occurred around 1850. With the restabilization of Kashmir after the Treaty of Lahore, many European manufacturers and merchants sent agents to Srinagar. This was particularly true of the French, who sent not only agents, but also pattern books, so that Kashmiri shawls could be made which had more immediate appeal for European taste (fig. 111). The rise of the crinoline skirt fashion, together with the increasing use of the Jacquard loom in Europe, had combined to produce a renewed upsurge of interest in shawls. Even at this stage there was kudos in owning an Indian shawl. Indeed, in at least one respect Indian shawls were to be preferred, since the interlocking of threads in the twill-tapestry production method led to a sturdier and more robust construction than did the clipped backs of the European weave. To meet the rise in demand, Kashmiri producers looked for quicker ways of making the shawls. A new production technique evolved in which several men worked at once, each producing small, irregularly shaped pieces which a seamster would sew together in such a fashion that no evidence can be seen on the right side of the fabric. As a result, many of these later Kashmir shawls, which look fine when draped over the human form, refuse to lie straight if flattened out on a large surface. The designs look increasingly familiar to the Western eye, with the twill-tapestry weavers producing patterns which were obviously developed with the capabilities of the Jacquard in mind. The Kashmiris were, in fact, producing imitations of the French imitations of what had originally been their own product.

Inevitably, the European market began to tire of the surfeit of similarity it had created. The quality of the Kashmir product deteriorated under the pressure to produce more quickly, and the mass

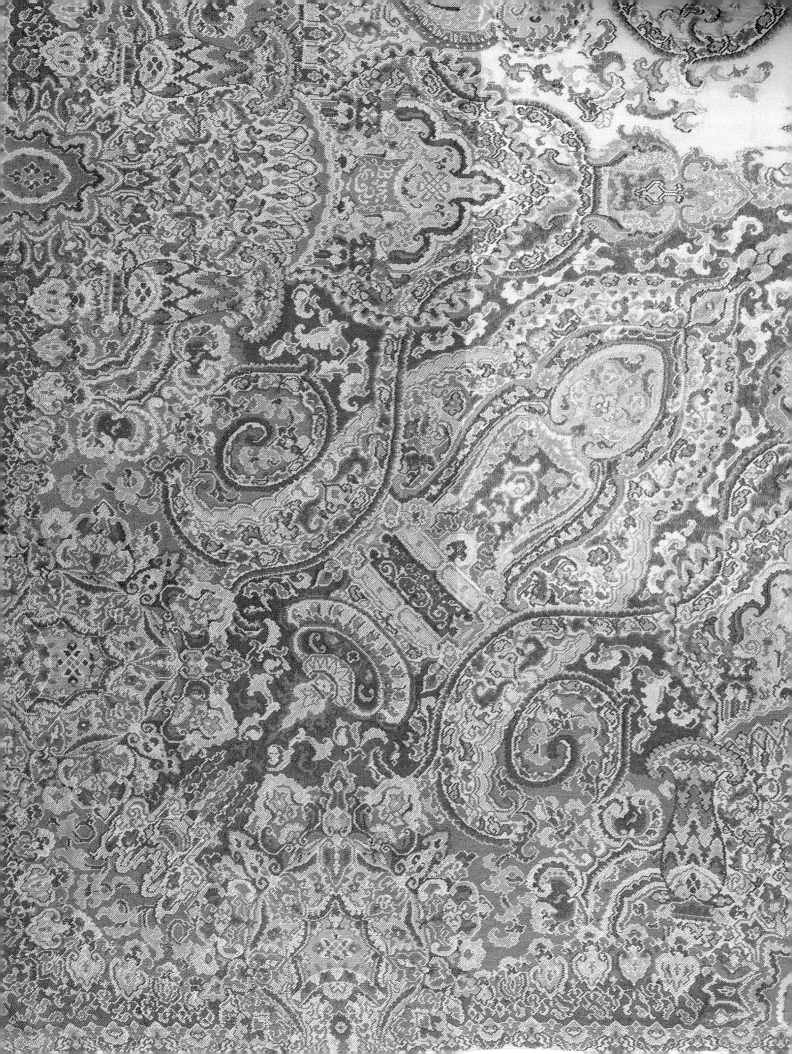

NOTES

1. Quoted in Irwin.

2. "Cutty Sark": short shirt;
"harn": a kind of coarse linen.

3. Quoted in Monique Lévi
Strauss, *The Cashmere Shawl*,
New York (Harry N. Abrams)
1988.

4. *Op. cit.*

5. Victoria and Albert Museum,
London, and Etro Collection,
Milan.

production carried out in Europe meant that shawls there no longer held the cachet they once had, particularly since cheaper, printed versions were now also available. A major change in European dress dealt the final blow to what, after all, had always been a fashion-dependent industry. By 1870 the crinolines, which had needed the large 400 × 200 cm shawls as outerwear, were replaced by bustle-skirts, which most decidedly did not. No fashionable lady would wish to hide the most attractive (and expensive) attribute of her new outfit – its rear view. The industry in Europe virtually disappeared within just a few short years, as manufacturers had to find new products, and displaced fancy weavers had to find new occupations. Shawls were redeployed as tablecloths or furniture drapes, a favourite use being as a decorative cover for the grand piano.

The design, however, survived the demise of the garment that had brought it to the fore. In Britain this may have been due largely to Liberty's of London, established in 1875 just as the shawl was disappearing, which adopted the paisley motif as one of its range of 'classic' designs. Liberty's have been producing variations of it ever since. Today the design never completely disappears. Even when not in high fashion, as happens periodically, the paisley is always to be found on men's ties and pyjamas. Is this the final irony, that a design originally found on a man's garment from India, which was brought to Europe as high fashion for women, has eventually settled on a man's sleeping garment with a name derived from two words of Persian?

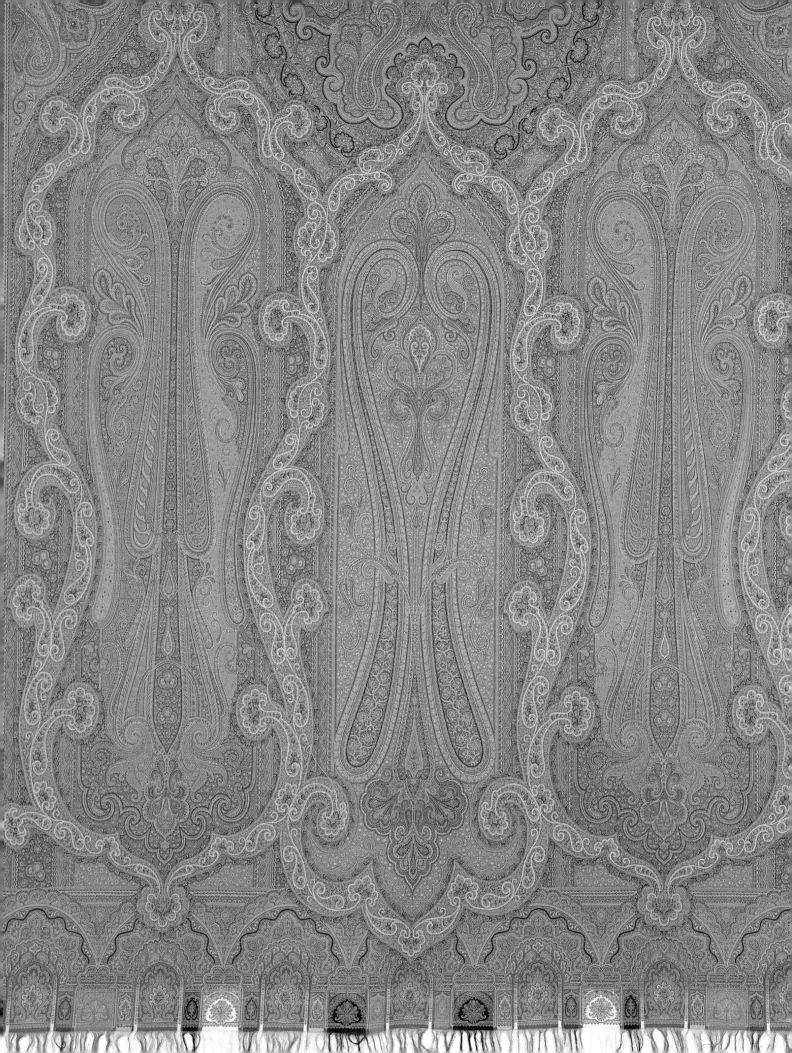

FURTHER READING

Aditi: The Living Art of India, exhib. cat., Smithsonian Institution, Washington, D.C., 1985

Alkazi, R., *Ancient Indian Costume*, New Delhi 1993

Ames, F., *The Kashmir Shawl and its Indo-French influence*, Woodbridge 1986, rev. 1988

Askari, N., and Crill, R., *Colours of the Indus: Costume and Textiles of Pakistan*, London 1997

Blair, M., *The Paisley Shawl and the Men Who Produced It*, Paisley 1904

Boulanger, C., *Saris: An Illustrated Guide to the Indian Art of Draping*, New York 1997

Clabburn, P., *The Norwich Shawl*, Norwich 1995

Crill, R., *Indian Ikat Textiles*, London 1998

Dar, S.N., *Costumes of India and Pakistan*, Bombay 1969

Dhamija, J., and Jain, J. (edd.), *Handwoven Fabrics of India*, Ahmedabad 1989

Dhamija, J. (ed.), *Woven Silks of India*, Bombay 1995

Elson, V., *Dowries from Kutch: A Women's Folk Art Tradition in India*, Los Angeles 1979

Goswamy, B.N., *Indian Costumes in the Collection of the Calico Museum of Textiles*, Ahmedabad 1993

Greenhalgh, P., *The Expositions Universelles, Great Exhibitions and World's Fairs, 1851–1939*, Manchester 1988

Guy, J., and Swallow, D., *Arts of India, 1550–1900*, London 1990

Irwin, J., and Schwarz, P.R., *Indo-European Textile History*, Ahmedabad 1966

Irwin, J., *The Kashmir Shawl*, Norwich 1973

Jacobs, J., et al., *The Nagas, Hill People of Northeast India*, London 1990

Jain, J., and Aggarwala, A., *National Handicrafts and Handlooms Museum, New Delhi*, Ahmedabad 1989

Jaitly, J., *The Craft Traditions of India*, London 1990

Kennett, F., *World Dress*, London 1994

Lévi-Strauss, M., *The Cashmere Shawl*, New York 1988

Lévi-Strauss, M., *Il Cachemire, Indian and European Shawls*, IV, Collezione Antonio Ratti, 1995

Lynton, L., *The Sari*, London 1995

Marg, xv, no. 4, 1962 [Handlooms]

Mehta. R.J., *Handicrafts and Industrial Arts of India*, Bombay 1960

Murphy, V., and Crill, R., *Tie-Dyed Textiles of India*, London 1991

Nabholz-Kartaschoff, M.L., *Golden Sprays and Scarlet Flowers: Traditional Indian Textiles from the Museum of Ethnography, Basel, Switzerland*, Kyoto 1986

Reilly, V., *Paisley Patterns: A Design Source Book*, London 1989

Reilly, V., *The Illustrated History of the Paisley Shawl*, Paisley 1996

Settina, N.H., *Shāl: Weaves and Embroideries of Kashmir*, New Delhi 1973

Steel, F.A., 'Phulkari Work in the Punjab', *Journal of Indian Art*, 2, no. 24, 1888

Varadarajan, L., *South Indian Traditions of Kalamkari*, Ahmedabad 1982

Varadarajan, L., *Traditions of Textile Printing in Kutch: Ajrak and Related Techniques*, Ahmedabad 1983

Watt, G., *Indian Art at Delhi, 1903, being the Official Catalogue of the Delhi Exhibition, 1902–1903*, Calcutta 1903

Wentworth, J., 'Kashmir, Indian and Paisley-Patterned Shawls', *Antique Collecting*, 27, no. 2, June 1992

PICTURE CREDITS

NASREEN ASKARI

Headshawls (pp. 4–5: top row, left to right: 1, 3, 5; bottom row, left to right: 2, 4, 5, 6), Turbans (pp. 12–13: top row, left to right: nos. 2, 3, 5, 6; middle row, left to right: 1, 3, 5; bottom row, left to right: 3, 4, 5), 16, 25, 33, 42, 43, 51, 52, 54, 55, 65, 68, 69, 71, 77, 79

ROSEMARY CRILL

Headshawls (pp. 4–5: bottom row, left to right: 3), Turbans (pp. 12–13: middle row, left to right: 2), 3, 4, 12, 28

ELLEN HOWDEN

2, 5, 7, 8, 9, 10, 13, 14, 15, 17, 18, 19, 20, 21, 22, 23, 26, 27, 29, 31, 34, 35, 36, 37, 38, 39, 40, 41, 44, 45, 46, 47, 48, 52, 53, 56, 57, 58, 59, 63, 64, 67, 70, 72, 73, 74, 75, 79, 80, 81, 82, 83, 84, 86, 88, 89, 90, 91, 92, 93, 94, 95, 96, 98, 100, 107, 108, 111

CAROL JONES

11

MOHAMMED ALI QADRI

Headshawls (pp. 4–5: top row, left to right: 2, 4; middle row, left to right: 2, 3, 4, 5, 6; bottom row, left to right: 1), Turbans (pp. 12–13: top row, left to right: 1, 4; middle row, left to right: 4, 6; bottom row, left to right: 1, 2, 6), 1, 21, 24, 27, 30, 32, 60, 61, 62, 66, 77, 85, 87, 92

PAISLEY MUSEUM AND ART GALLERIES

104, 105, 106, 109, 110

111
'Paisley' shawl, detail
European
ca. 1860
Woven cotton
L: 336 cm W: 168 cm
This typical late-period shawl exemplifies the synthesis of European and Kashmir design.

INDEX

References in *italic* are to figure numbers.

abochhini 39, *22, 23*
ahram 21
ajrak 8, 14, 39 *27, 60–62, 105*
alfi 91
amli 39
amru 30
angrakha 21

bagh 47
bandanna 99, *95, 102, 103*
bandhani 8, 29, 39, *26, 58, 94*
bepassi 39
bhujki 84
block printing 23, 39, 42, 65, *90, 98*
blouse 8, 21, *28*
bodice 21
bokano 42, *31*
breastcloth 51, *50*
bunyan 21
bushkiri 84

canopy 84
cap 8, 65, *55*
chadar 8, 21, 23, 39, *40, 45, 76*
chikankari 8
choli 21
cholo 8
chundari 8
chunri 26
coverlet 84, *87*

dastarkhwan 84, *89*
dhablo 39
dhabro 39
dhoti 20, 21, *28, 74–76, 65*
doosa 51
doshalo 8, 21
dowry bag 84, *83, 84*
dowry cloth 21, 84, *81, 82*
dupatta 8, 21, *21, 51, 47*

embroidery 8, 23, 39, 42, *29, 47, 31, 32, 34–37*, 51, *39, 41, 45*, 65, 55, 76, *75, 78, 79–84*, 84, *87, 93, 99, 103*

gaghra 21 23, *28, 76, 76*
gaj 8
gandi 8, 21
ganga jamna 51
gharcholu 21, *2*
gothro 83

handkerchief 8, *64, 99, 100, 102, 103, 107, 109*
headcloth *56*
headshawl 8, 21, 39–51, *21, 24, 51, 47, 70*
hikpassi 39

ikat dyeing 23, *4, 8, 9, 12*, 51, 64, *104, 105*

jacket 20, 51
jaconet 108
jamdaani 30, 36, *20, 51*
jerkin 91

kafan 21
kalabatun 29
kambal 51, *42*
kameez 21
see also *shalwar kameez*
kanchirani 30
kani 39
kathi 23
kediyun 28
khato 39
khes 84, *88*
kornad 29
kulah 65, *55*
kurta 21

lacha 74, *67, 70, 72*
lappet 108, *109*
leheriya 65
loincloth 20, *74–76*
ludi 42, *28–30*
lungi 21, 23, 65, *51–53, 74–76, 71, 73*

maizposh 84
maleer 8, 42
mashhadi 65
mekhala 23
mull 108
muster 104

nivi 23

odhani 8, 21, 23, 39, *94*

pag 8, 65–67, *57, 58*
paghri 65–67, *58*
paijama 21
pairhan 21
paisley pattern *94, 113–25, 105, 106, 108, 110, 111*
pakkoh 42
palan 23, 30
palangposh 87
pallu 23, *10, 19*
parha 76, *77, 80*
pashk 51
pashmina 39
patka 65–67, *59*
patolu 23, *8, 29*
patti 51, *44*
pattu 51, *38, 46*
petticoat 21, 23
phaneyk 76, *75*
phulkari 21, 47, *34–37*, 51, *39, 41*
pomcho 26
poti 8
pushti 8
puthkalli 79

qanat 84, *90*

resist dyeing 23, *6*, 39, 42, *27*, 65, *58, 89*
see also *ikat* dyeing, tie-dyeing
riah 51, *50*
rumal 8, *64, 85*

safa 65
salara 14, 42, 47, *33, 68*
salari 42, *32, 74, 70*
sari 20, 21, 23–36, *2–10, 12–20*, 51
end-piece 23, *7, 10, 30, 19, 20*

sash 20, 42, *31, 67, 59*
scarf 42, *31*, 85, 108, 113
screen *90*
shah tus 39
shāl 113
shalwar 21, 51
shalwar kameez 84
shamiana 84
shari 51, *43*
shawl 8, 14, 20, 21, 39–51, *25–30, 32–40, 42–46, 48, 49, 76, 68, 99, 94, 100, 104, 113–25, 104–11*
shoulder cloth 20
skirt 21, 23, *24, 74–76, 76–78, 80*
spread 20, 84
suri 8, 51

tablecloth 84
telia rumal 9
thalposh 81, 82
tie-dyeing 8, 21, 29, 39, *24, 26, 29*, 65, *58, 94, 102, 98*
see also resist dyeing
topi 65
trousers 8, 20, 21, 51, 84
tunic 8, 21, *28*, 51, 84
turban 8, 14, 20, 21, 39, 42, *25, 28, 65–67, 51–55, 57–63*, 113
Turkey-red dye 99, *94, 101–03, 96, 104, 108–09, 110*
turro 67

uttariya 20

veil 21, 42

waistcoat 51
waistcloth 20, 21, 23, 39, *25 28, 74–76, 65–67, 69–75, 79*, 113
see also loincloth
wall-hanging *92, 102*
wall panel 84
wrap 20, 84

zardozi 29, *11, 21, 92*
zari 29, 30, 51